THE INNOCENT ›

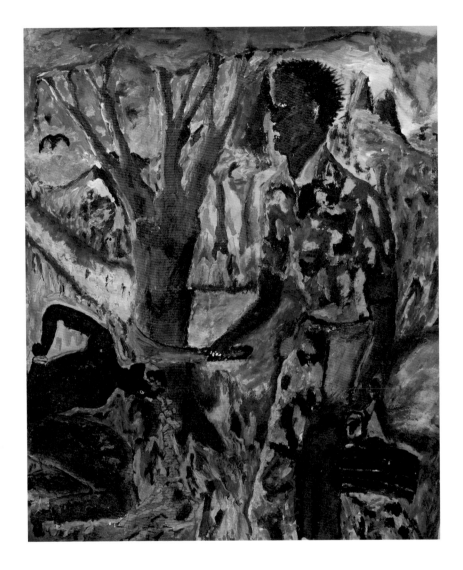

Formerly Abducted Child's Therapy Drawing, Rachele Rehabilitation Center, Lira, 2005

"WHOEVER HAS SUCCUMBED TO TORTURE CAN NO LONGER FEEL AT HOME IN THE WORLD. THE SHAME OF DESTRUCTION CANNOT BE ERASED. TRUST IN THE WORLD, WHICH ALREADY COLLAPSED IN PART AT THE FIRST BLOW, BUT IN THE END, UNDER TORTURE, FULLY, WILL NOT BE REGAINED. THAT ONE'S FELLOW MAN WAS EXPERIENCED AS THE ANTIMAN REMAINS IN THE TORTURED PERSON AS ACCUMULATED HORROR. IT BLOCKS THE VIEW INTO A WORLD IN WHICH THE PRINCIPLE OF HOPE RULES. ONE WHO WAS MARTYRED IS A DEFENSELESS PRISONER OF FEAR. IT IS *FEAR* THAT HENCEFORTH REIGNS OVER HIM."

JEAN AMÉRY, AT THE MIND'S LIMITS: CONTEMPLATIONS BY A SURVIVOR ON AUSCHWITZ AND ITS REALITIES

TO GIVE VOICE TO THOSE WHO DESIRE TO BE SEEN AND LOVED

The British Airways flight that released me from Fall's crisp edge and into the heat of equatorial Africa also freed me from the life I'd known, depositing me onto that road less traveled. It was thus that I arrived and began weaving very tenuous threads of a new way of life, which enticed me to stay in northern Uganda for nearly a year. Initially pursuing a desire to focus on humanitarian relief work in Kampala, in the south, I was led to months of travel throughout the northern part of the country. Uganda has seen much suffering, and it was no less heartrending to absorb and comprehend the complex history, progression, politics, tribal background and extraordinary brutality that were taking place in the ongoing civil war. Words that roll off the tongue with brutal bluntness became far too familiar: abduction, rape, child soldiers, sex slaves, mutilation, IDP camps, landmines, psychological trauma, genocide.

For more than twenty years, civil war in the north has claimed women and children as its primary victims. It is estimated that the Lord's Resistance Army (LRA) has abducted as many as 66,000 youths, wrenched them from their families and forced them to become soldiers, porters and sex slaves. Up to 80% of the LRA rebels are children below 20 years of age. Led by psychopath Joseph Kony, an Acholi who claims to defend the rights of all Acholi people by waging war against the Ugandan government in the name of the Ten Commandments, the LRA has instead inflicted grotesque carnage and senseless chaos on them. Yet, whilst protecting the population of the north,

the Ugandan military has perpetrated its own share of massive human rights abuses. At the peak of the conflict, spread out over 80% of the region, two million Ugandans lived in massive squalid camps, lacking access to basic sanitation and resources, and hundreds of thousands still subsist in these camps today. Tens of thousands of defenseless civilians were butchered and cultural traditions were severely weakened. After years of stalled peace talks, failed military attempts to apprehend Kony (now indicted as a war criminal by the International Criminal Court), and Kony's subsequent retraction and insurgency into other regions, northern Uganda may no longer be officially at war, but neither is it psychologically at peace.

I was asked what I would be willing to reveal of myself in this work. Much, I had thought; but there was no way I could truly understand what that would look like. The human reality—our psyche and emotions—is a complex mixture of intent, memories, hopes and ideals. The children I encountered were truly the most difficult to comprehend. Many had been forced to commit horrific acts against fellow townspeople, villagers and family, and the words "innocence lost" seemed grossly naïve and under-serving. We are all haunted in varying degrees by past events and long for a more hopeful future, and on this middle ground my own complex feelings of empathy and sympathy surfaced. But the depth of tragedy permeating every aspect of life in Uganda bordered on the incomprehensible.

My photographic journey began in the northern districts of Lira, Kitgum, Gulu and Pader in 2005, where my senses were indelibly marked by everyday realities. The crackling wet whisper of babies coughing in oppressive IDP camps; the acrid stench of body fluids and wounds swathed in bandages in overwhelmed and congested hospitals; children curled together in shelters on tarpaulin-covered floors trying to escape abduction; hushed voices in rehabilitation centers as children intoned tales of forced brutality, their weary stares seeking a few gentle moments of comfort.

I returned for the third time in February of 2009, and left with more encouraging visions. Children in brilliantly-colored school uniforms screaming with laughter on playgrounds; adults tending fields of cassava, sim-sim and groundnuts; cell phones, solar panels and second-hand designer clothing visible in the towns, camps and villages. Civil war, major human rights abuses and inhumane living conditions are now giving way to reconstruction and development, to basic infrastructure for education, to germinating psychosocial and medical support services, and to landmine clearance and explosive ordnance disposal. Long-term recovery and reconciliation processes take time and aspects of each will be entangled in the other for decades to come.

As they say in the north, "slowly, slowly."

Ultimately this book is a vessel born of love. It testifies to the suffering and dignity of a particular group of people in one part of the world. But look a little deeper into their eyes, and it is a reflection of us all in one guise or another. Each of us can do little things to change the world around us even if we can't singlehandedly solve its larger problems. Individual acts grow to have great collective power. I believe this to be true. Even if it simply means we heal ourselves first. There will not always be answers for everything else.

It was a gift to bear witness to the people of northern Uganda whose lives profoundly touched me. This is my love letter to all the forgotten, displaced, abducted, sexually assaulted, mutilated, abandoned, lost and tortured souls, both literally and figuratively, who desire to be seen and loved. It is a visual "wish" thrown into the collective deep blue unknown, that each of us might hold true to some measure of hope, dignity, and strength in the face of fear, adversity and loss.

I had wanted so much for this to be about serving others, to be about "them." But the deeper truth is that, like all quests where we invest our heart, they become humbling personal journeys as well, with chance, choice and consequence added along the way. Like others, I hunger and am restless for intimacy, purity and hope, seeking visual evidence that we are all one. What began in part as a need to give voice to my own inner struggles, and as a wish to do the same for those who long to be seen and loved, evolved into a desire to express the sense of self we all share:

I am more than this.

THE INNOCENT CASUALTIES OF THE CIVIL WAR IN NORTHERN UGANDA

HEATHER MCCLINTOCK

SCHILT PUBLISHING, AMSTERDAM

My beloved is small, oh,
She is small and truly beautiful;
She is small,
My love, oh,
She is small,
Grow up slowly my love, there is no hurry,
Oh my love.
Ugandan love poem by Okot p'Bitek

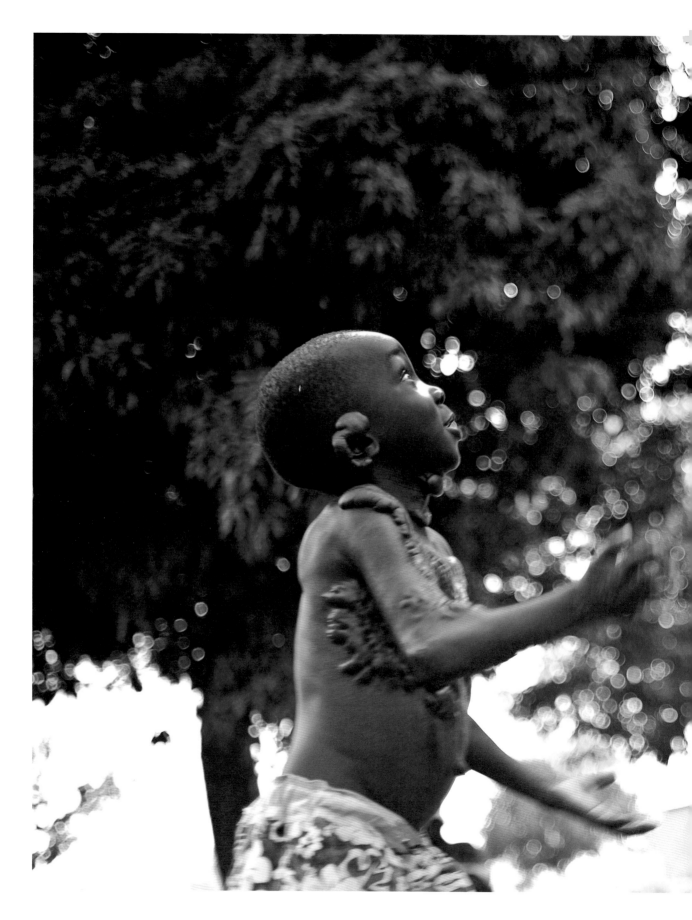

King David, Lacor Hospital, Gulu, 2007

Kala Rose, Tyer IDP Camp, Pader District, 2007

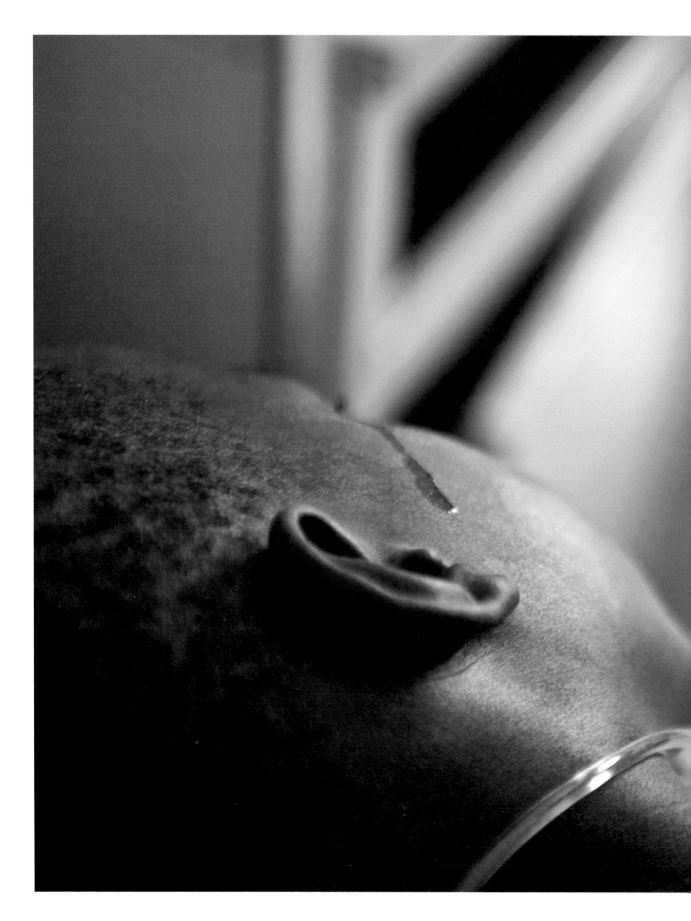

Okot Simpol, Recovery Room Lacor Hospital, Gulu, 2007

APIO SOPHIA ›

In August 2003 on a fateful morning, when I left camp together with my husband and ten other people to move back to our village in search of food, the LRA attacked and killed my husband together with the others. I was made to play with his dead body. I survived being killed because I was the last person in line. My mouth was chopped and I was sent by the rebels to report to the government troops about the LRA presence.

I went through multiple operations and treatments for the wounds. I went through very hard and painful eating and I couldn't easily open my mouth to talk. Since the crime committed on me, life has been compounded even more with pains, stigma, dependency and being a widow. Many people who met me wished I been killed rather than being left in such pain. Likewise when my mouth was closing up and I had tried many hospitals but all seemed unwilling to help me since I appeared so vulnerable and such a burden to them. Referrals to other hospitals were made but it required finances which I didn't have at all. As I was battling with my pains, my two remaining children living in the camp were also abducted and killed by the LRA, and from then I deeply regretted having pleaded to the rebels not to kill me.

My beauty has gone and I am not going to reclaim it again, but it has already happened and I have to look ahead until the time I will finally be dead. I loved life, but my love vanished after all the atrocities done to me and other people from northern Uganda.

I know assistance can never undo the injustice done to me, but it has helped me in my struggle with my acceptance in society. I knew nothing about war, but so sad that, innocent as I was, I am a victim of world-class torture. If my torture was to win the LRA award, my torture must have won them the world championships. Their legacy will continue, they will forever be remembered as the world-class enemies of humanity. I cannot forgive the LRA, they have killed me, I am sad.

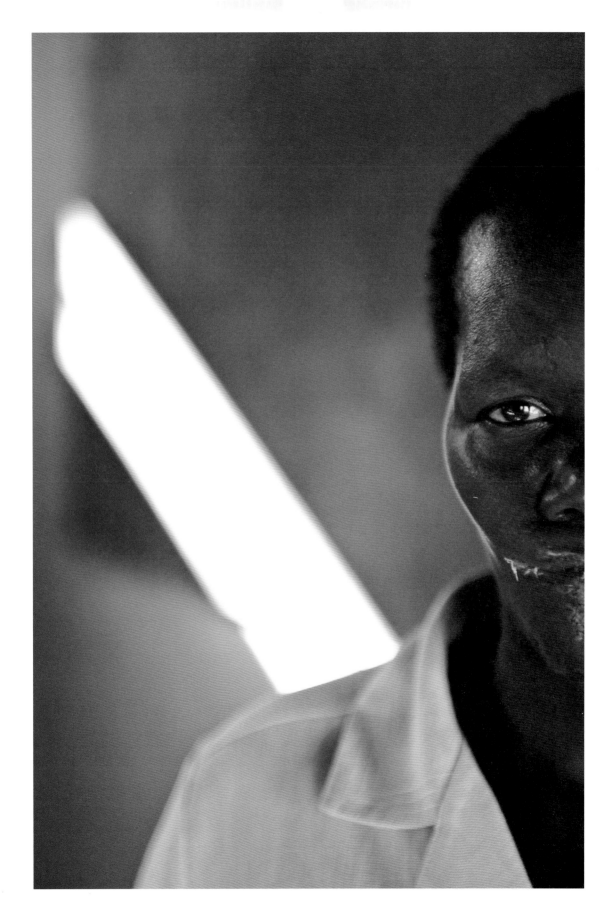

Apio Sophia, Lacor Hospital, Gulu, 2007

After School Athletics, Keyo IDP Camp, 2009

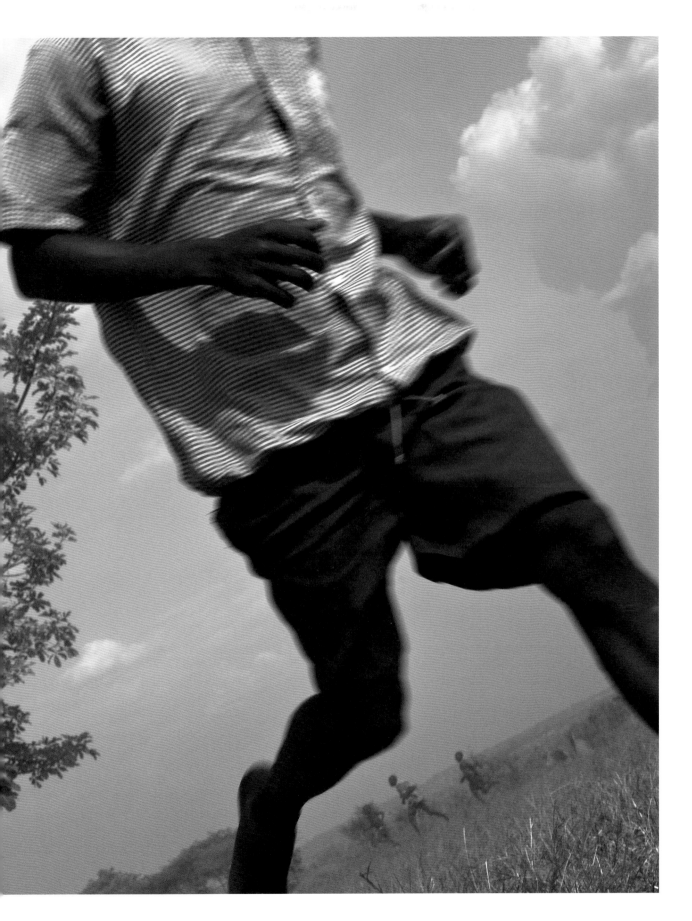

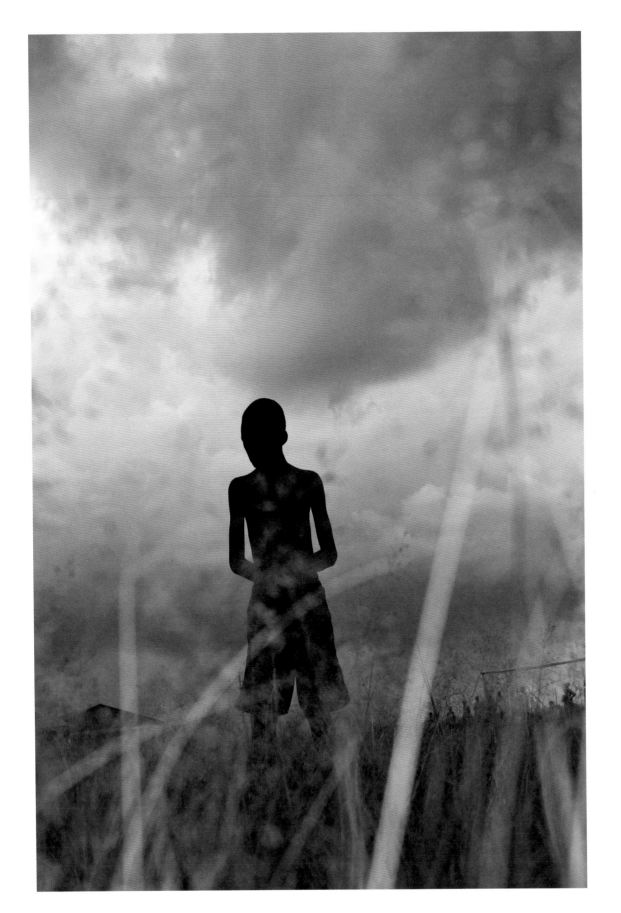

Ugandan Daydream, Lira, 2005

KOMAKETCH JOSEPH
OJOK ALEX
ACIRA ALEX ›

We are tired of fighting. We surrendered to the UPDF yesterday and are in their Child Protection Unit, but don't know how our families will feel about us, or if they will even accept us. When we were captured by the LRA we were told they would kill us if we tried to escape, or the government would persecute us if we were caught. Many others were killed while trying to escape. You would be made to use a stick to beat someone until they were dead. It was not easy.

Komaketch Joseph: I am seventeen years old and was abducted eight years ago from home when I was in Primary 2. I have shrapnel in my left leg. Acira and I were in the same battalion. I would like to go back to school.

Ojok Alex: I am twenty-five years old and was abducted fifteen years ago from home, when I was in Primary 3. I was a big man, a Lieutenant in the LRA and could order others to get me food and water. I was in the "big camp" with Kony and travelled back and forth from Sudan. I have had two wives and a child. I heard my mother has died and my father is a soldier with the UPDF and has a new wife. The UPDF have welcomed me back, happily, and I would like to join them.

Acira Alex: I am sixteen years old and was abducted nine years ago while at home from school on a holiday. I was in Primary 2 and would like to go back to school now. I have a bullet in my right arm and swelling in my leg.

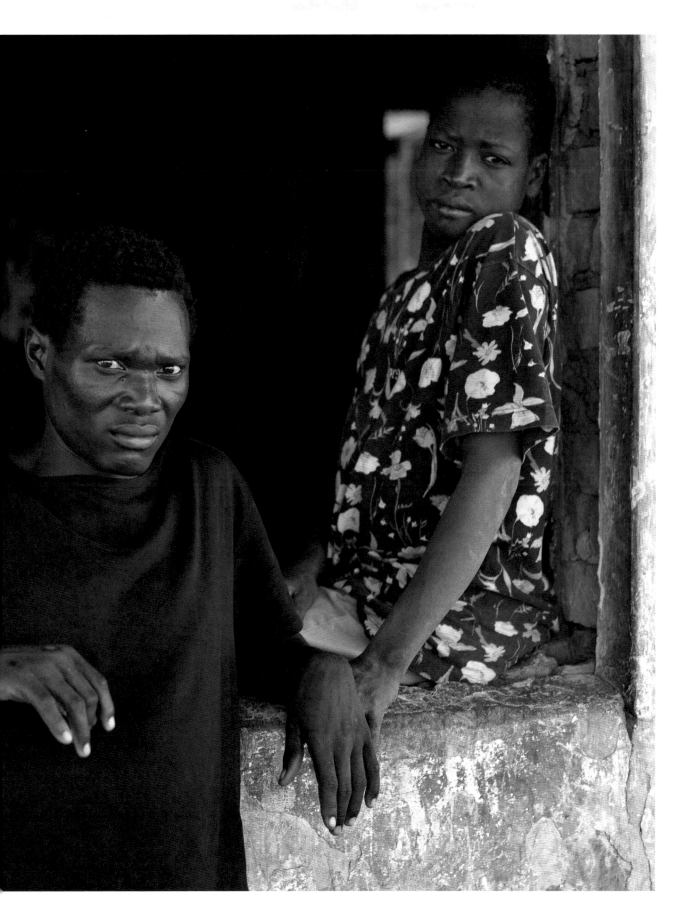

Night Commuter Dream, Noah's Ark, Gulu, 2006

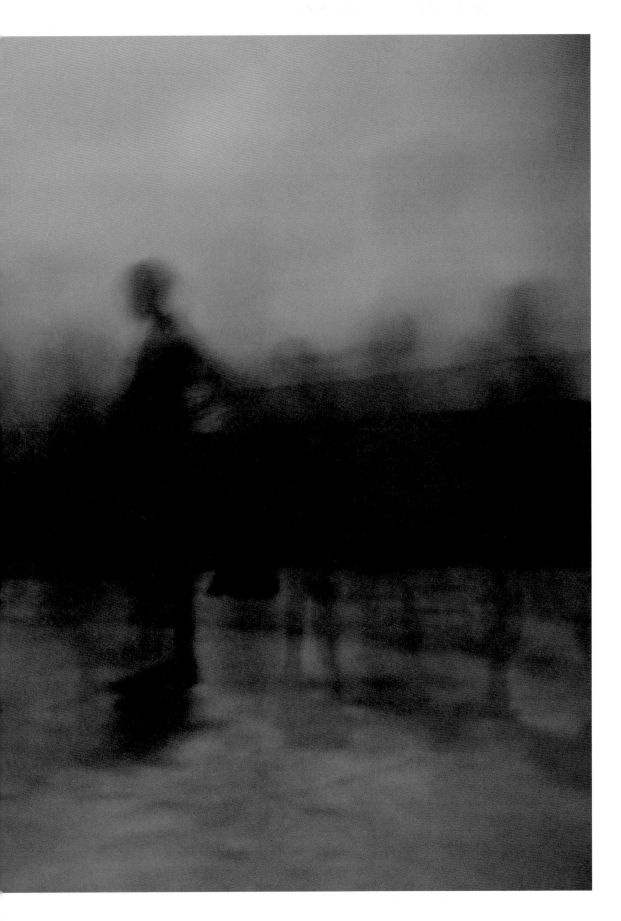

Safely at Rest, Noah's Ark, 2006

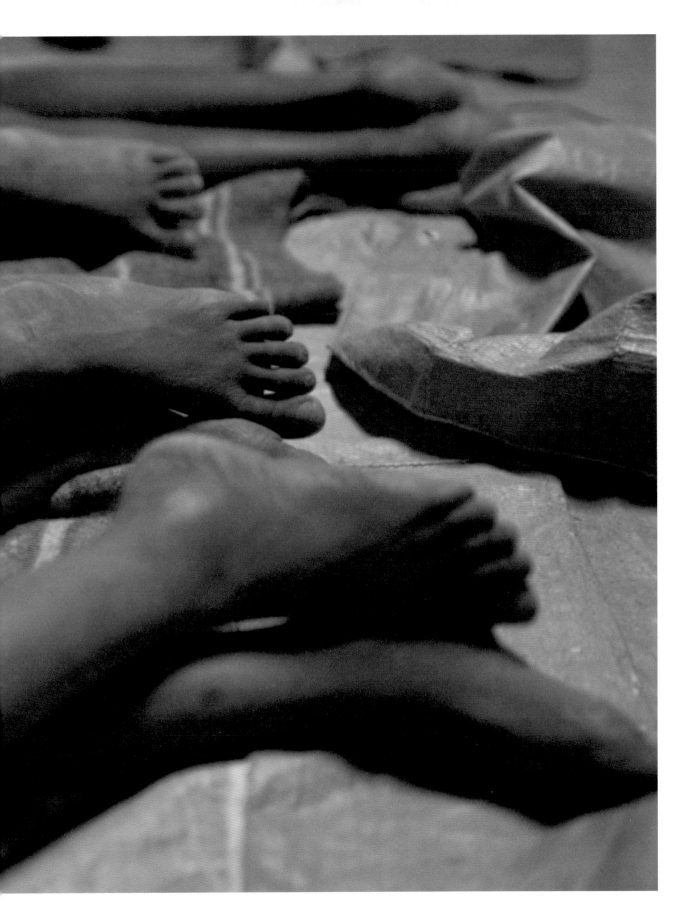

UPDF Escort, Pader District, 2005

The Dry Season, Parabong IDP Camp, 2009

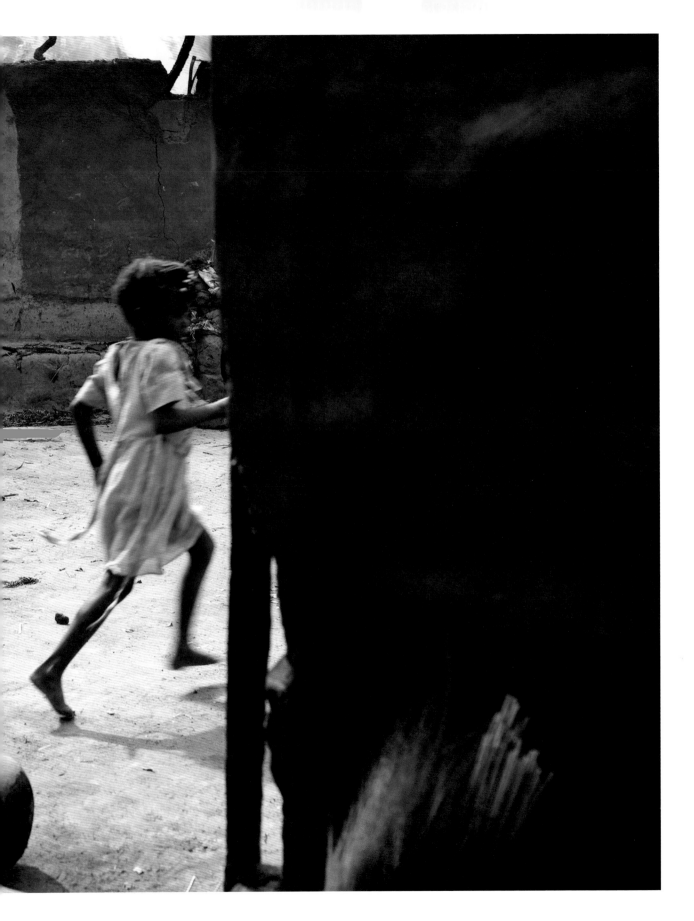

Akidi Janet and her Grandmother, Kitgum Hospital, 2005

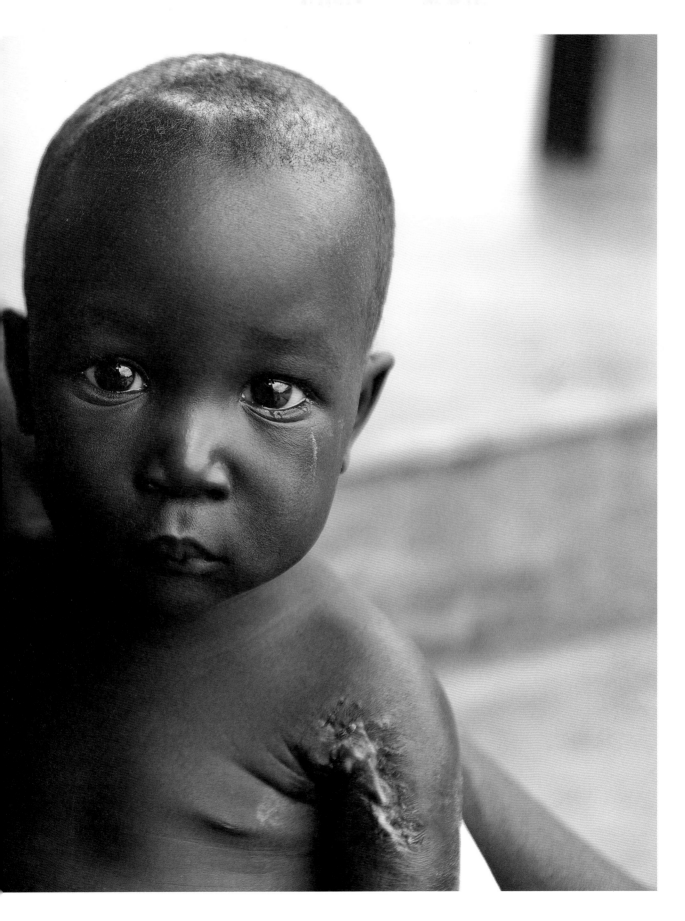

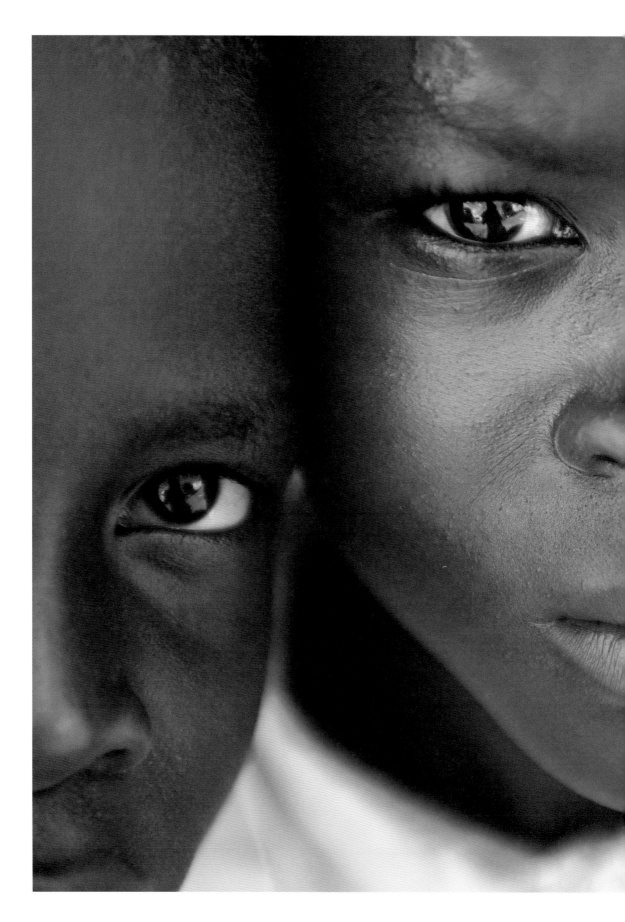

Youth of a Nation, Lira, 2005

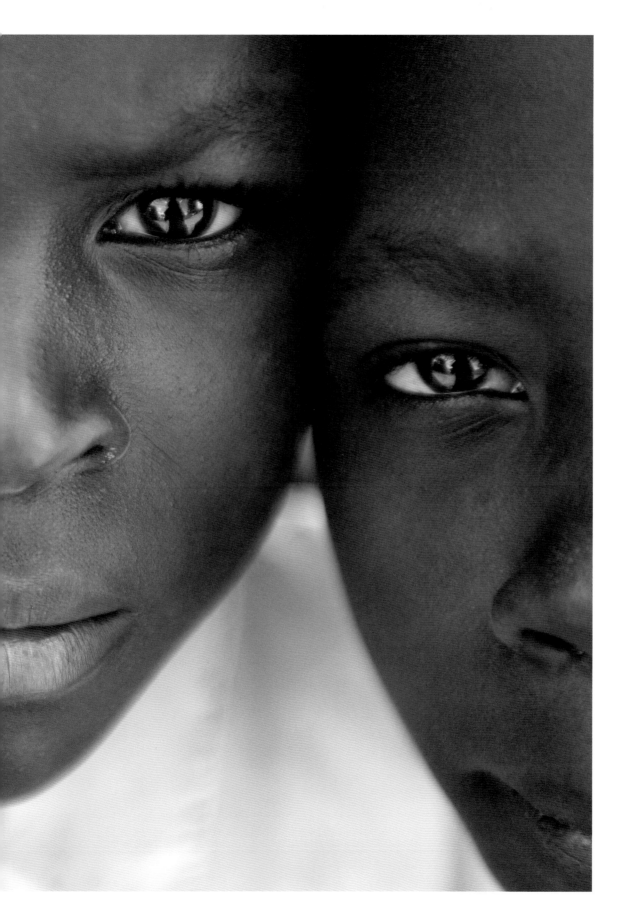

Abalo Joyce, Lacor Hospital, Gulu, 2006

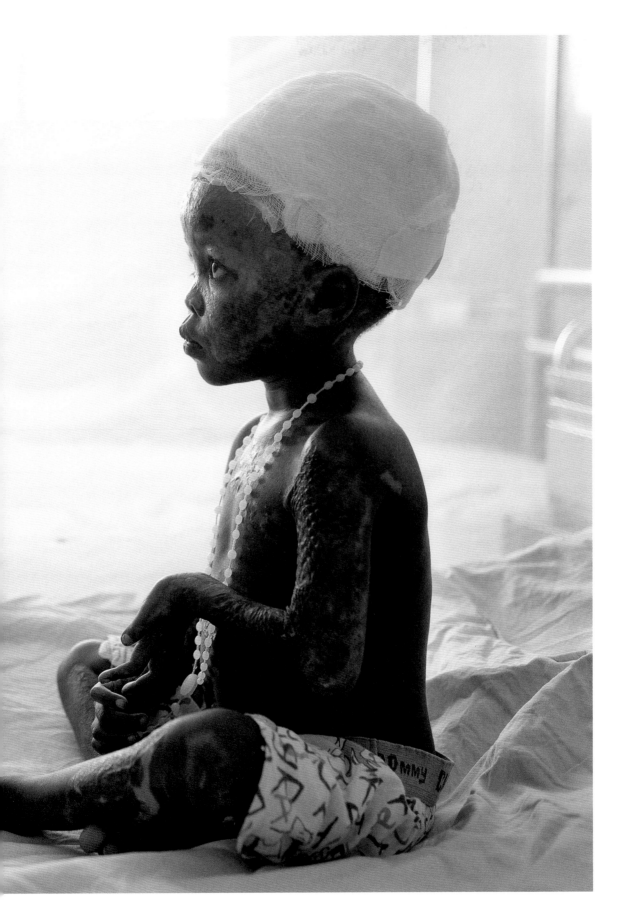

Memory Verse, Lira, 2007

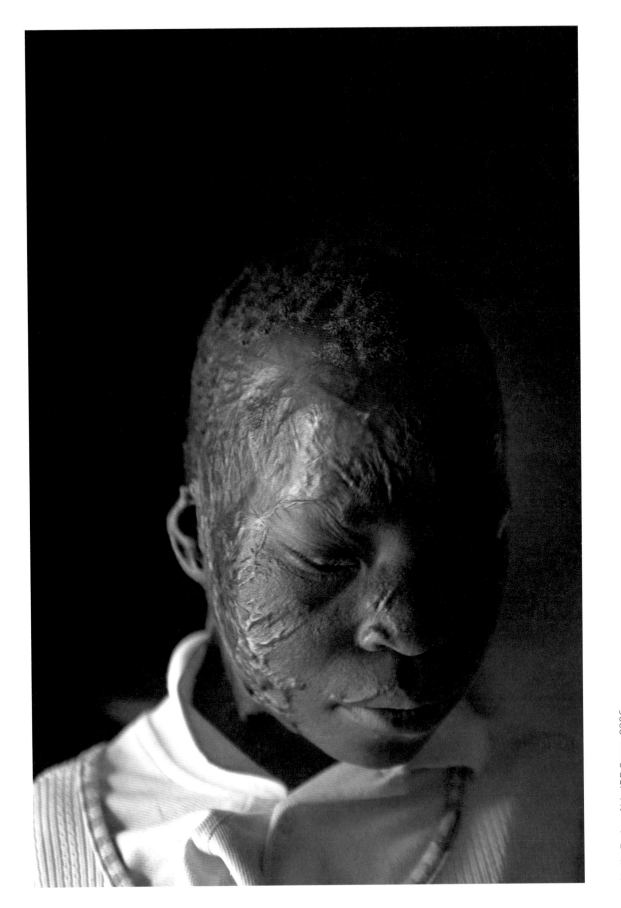

Akullu Evelyn, Abia IDP Camp, 2006

AKULLU EVELYN & AKELLO MILDRED ›

Mildred: On February 4th 2004 we were pushed into the house and set on fire by the rebels. I lost a son in the attack. I always put aside and, in most cases, ignore my pains to care for my daughter. It's devastating to live a failed life, a life where a mother like me cannot afford to raise her own children due to injustice done to her. It's a massive loss to my family and much as I try to comfort my daughter daily, she is getting mature and realizing how her disfigurement will be a challenge for her future. She can't study because I can't raise money, and it is not going to be easy for her to get married and have her own family. Regrettably, my disfigurements, desperation, and general family vulnerabilities forced my husband to desert me. Now amidst all the problems, I still have the responsibilities of a father and a mother. I needed multiple surgeries; my daughter was terribly in need of assistance and to date I am medically banned from performing hard labour such as digging, fetching water and other domestic work. But the needs are alarming and with no option, I have to shun most of the medical recommendations. I have lost any sense of my home, to be free, to be happy, and it's hard to feel safe anymore. I feel I just escaped death for a reason I don't understand. Maybe it's a chance that I should support my injured children.

Evelyn: Up to now I do not understand why I was tortured and given these disfigurements, or how the rebels have benefited from torturing us. My life will not be easy for sure, but I have no choice but to live the life I have now. I am sad about how I look, I am sad that we lost everything, I am sad that I dropped out of school, I am sad that life might get worse for me.

I keep excellent memory of all my pains. I go through nightmares; my mother tells me that I scream at night, I don't see life getting better at all. I do fear for my mother, she is very sick and weak yet she ignores doctors' instruction for her to do a lot less work but she makes sacrifices for us and risks her life.

It's very important to study, but if we can't afford it, then we have no choice but to let go. If I had power, I would do whatever it takes to pay back my mother who tried to save me, even the day we were attacked, she protected me with her own body. We both need one another, so she shouldn't do things that put her life in danger.

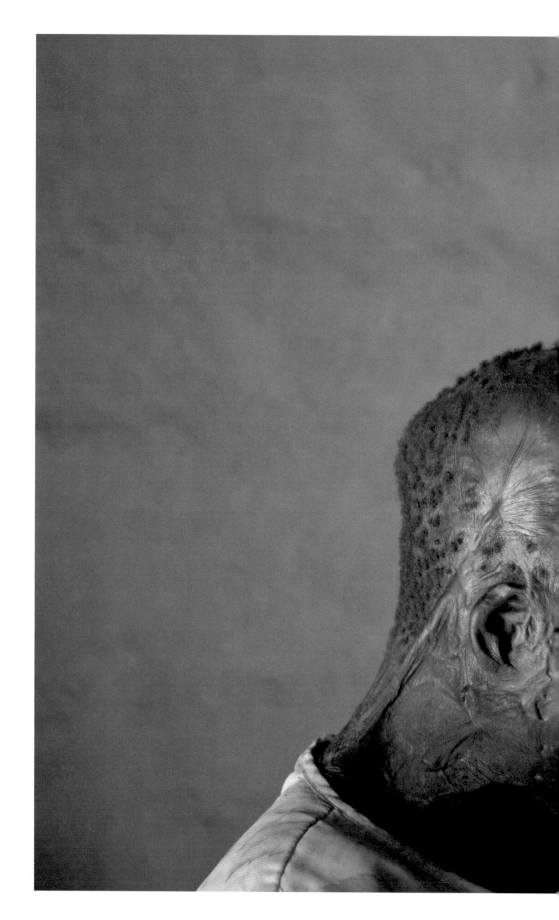

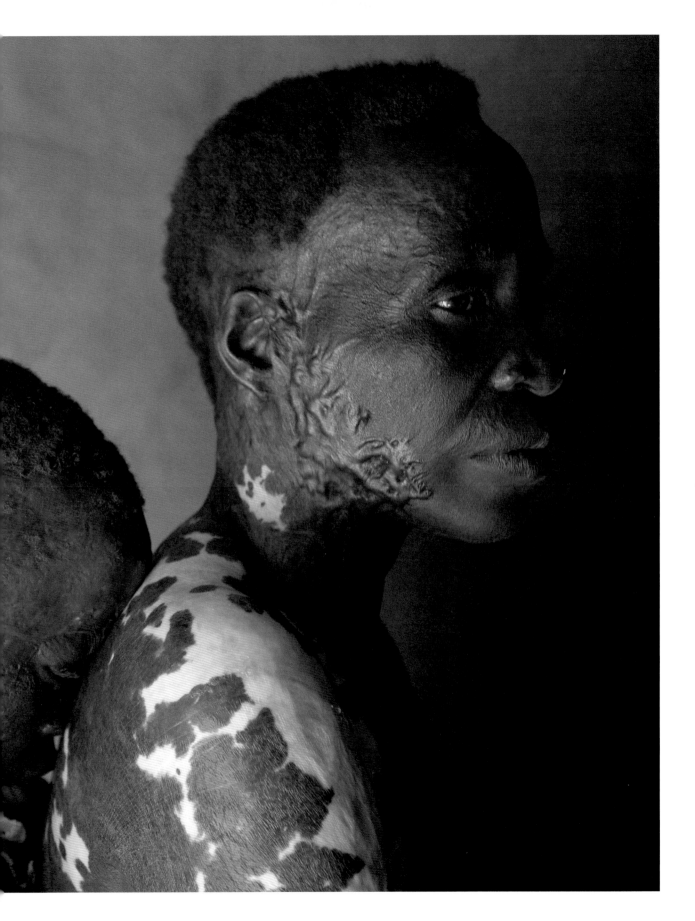

UPDF Returning from Patrol at Day's End, Pader District, 2005

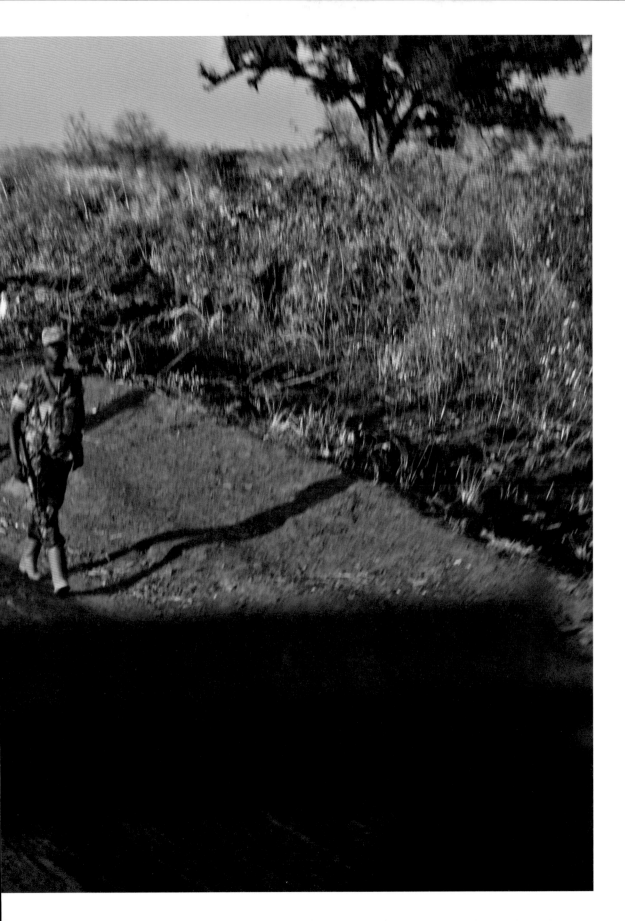

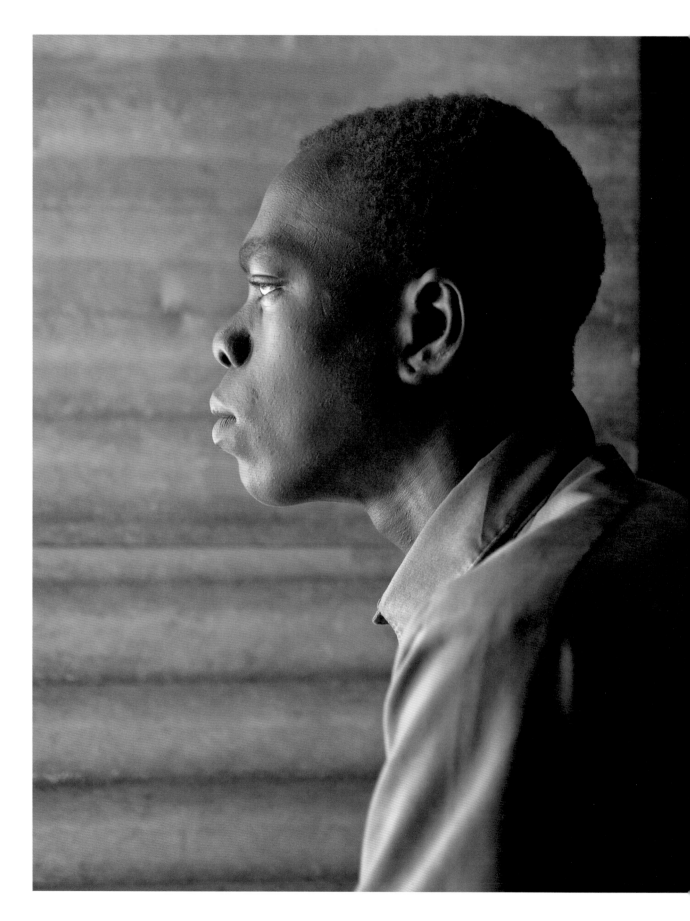

Omara Tony, Abia IDP Camp, 2006

Aciro Milly, Lacot Gladys, Akello Kevin, Lamwaka Sandy, Cwero Primary School, 2009

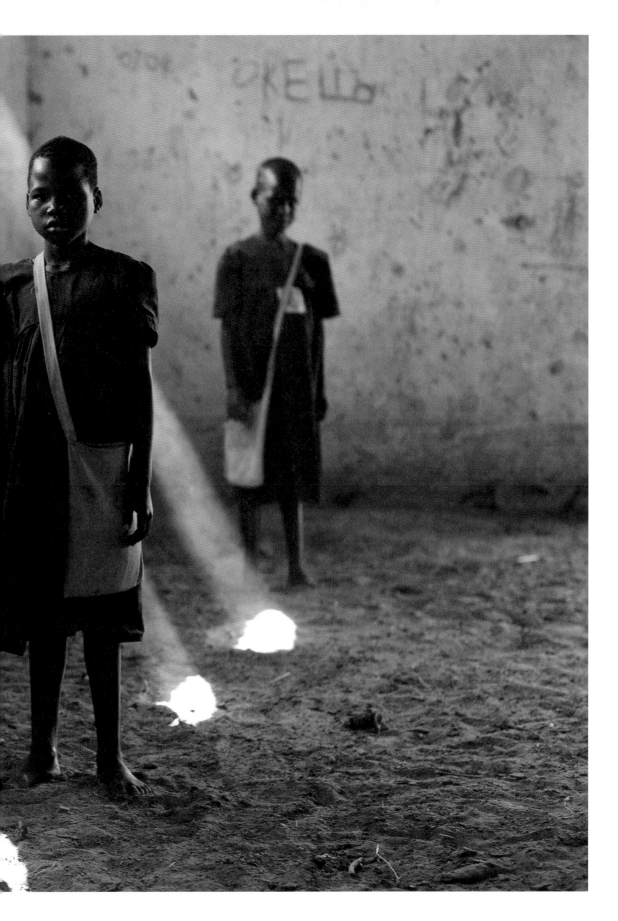

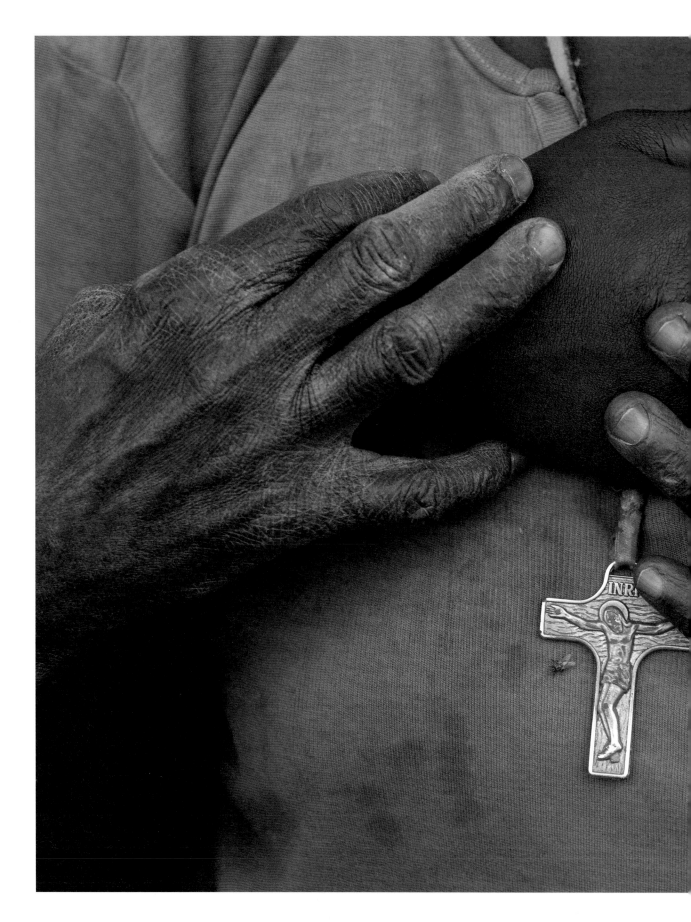

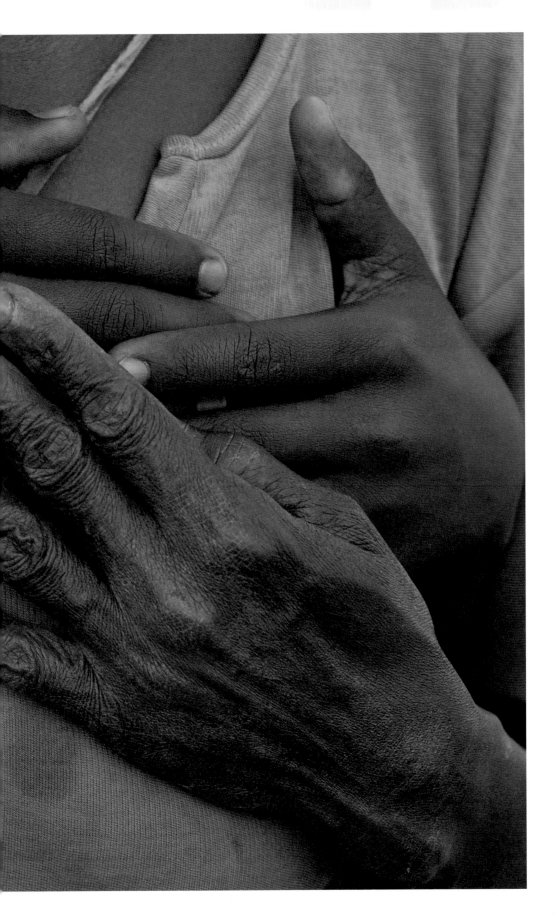

Adong Jennifer and her Grandmother, Palyec Village, 2009

ACIRO MARGARET ›

I came to live at Paicho camp in 1999 when the UPDF were chasing people away from their homes by throwing bombs into the villages. The rebels were around and the UPDF wouldn't allow us to stay. On 23rd May in 2005 I went to the garden in the morning with other women, and fighters of the LRA surrounded and captured five of us. We were led underneath a tree and beaten with our hoes. I was taken away from the other four and was made to watch as they were killed, one by one, until they finished them all…cut in the back of the head with our own garden hoes. Sometimes I dream about them being killed, and then I pray.

During that time I was pregnant and the LRA normally respect mothers. Their women give birth in the bush, so they believed that if they killed me it would be bad luck, their women would also die. They used a razor blade to cut my face. There were twelve in total, all with guns, but the commander, who was sitting and just watching, chose four young boys, between the ages of thirteen and fifteen, to do the job. I witnessed the four dead bodies lying there, and as they were cutting me I didn't feel as if I was in my body. I felt no pain. After they completed their work, the Commander sent me back to the camp, because I was bleeding seriously and if I were to die from the cutting, he wanted me to die away from there. I felt a lot of pain when a man carried me 2 km back to the camp on his bicycle. I have been operated on five times. My husband refused to see me after the incident and does not love me anymore. He sent me away and will not help me take care of the children. My children are aware of what happened, they saw me bleeding on that very day and the older one ran away because she was scared. Afterwards I met one of the boys who had escaped at a rehabilitation centre; he said he was not one of the ones that had done this to me, he was worried and laughing, but later asked for forgiveness. I was angry at his laughter but forgave him.

People look at me, but they have no words. My children are what make me very happy.

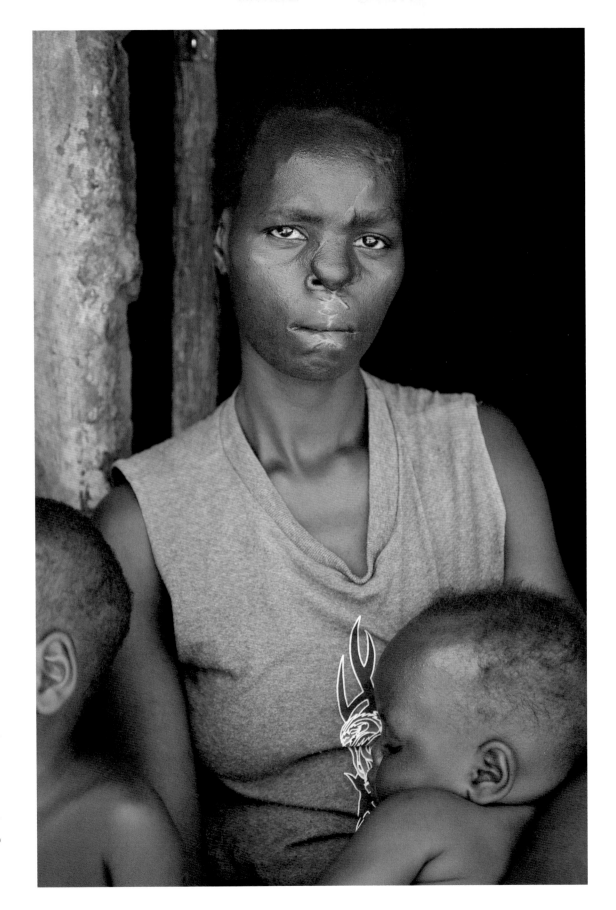

Aciro Margaret, Paicho IDP Camp, 2006

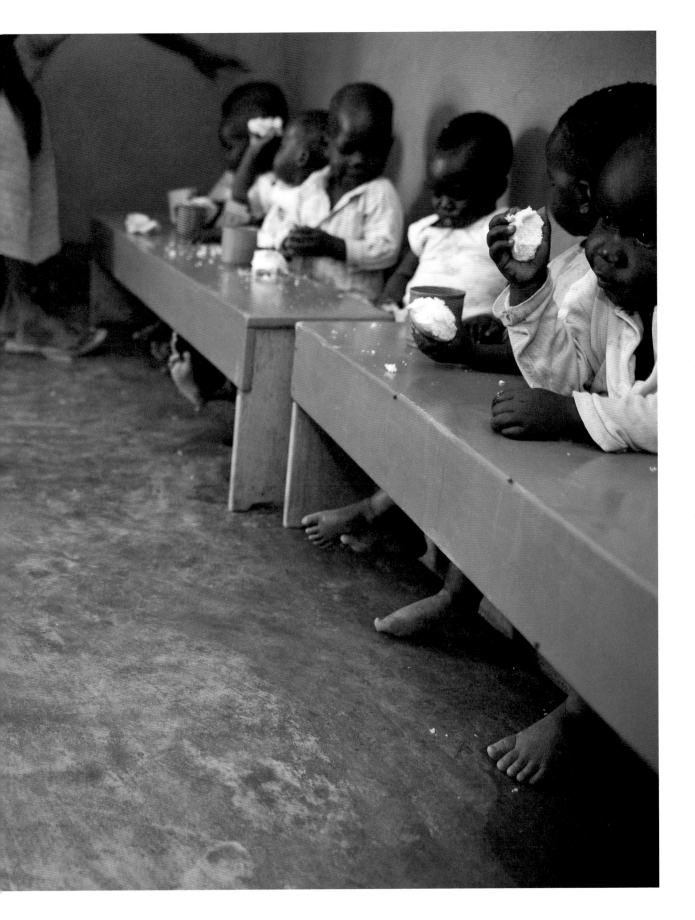

Okwera Richard, Gulu Hospital, 2006

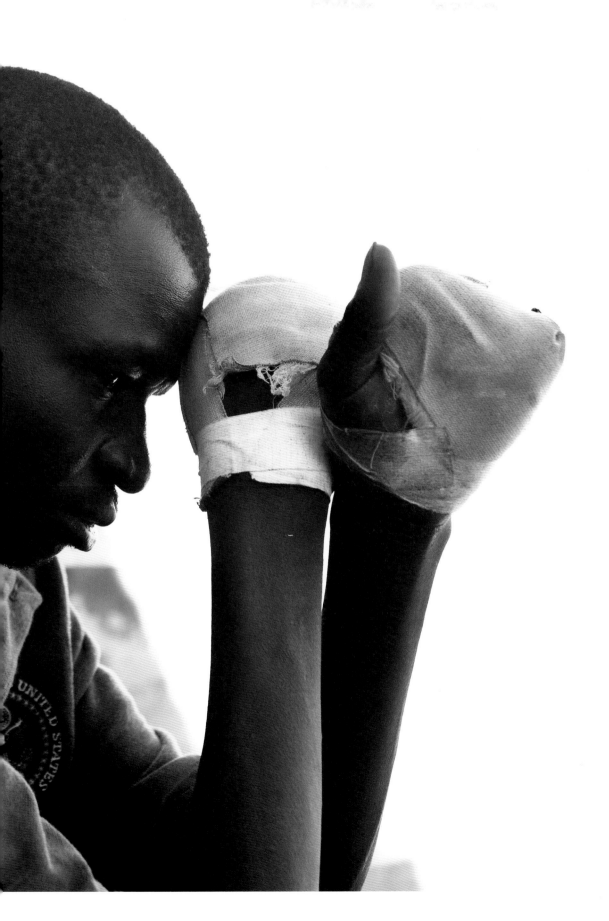

Rachele Rehabilitation Center Chalkboard, Lira, 2007

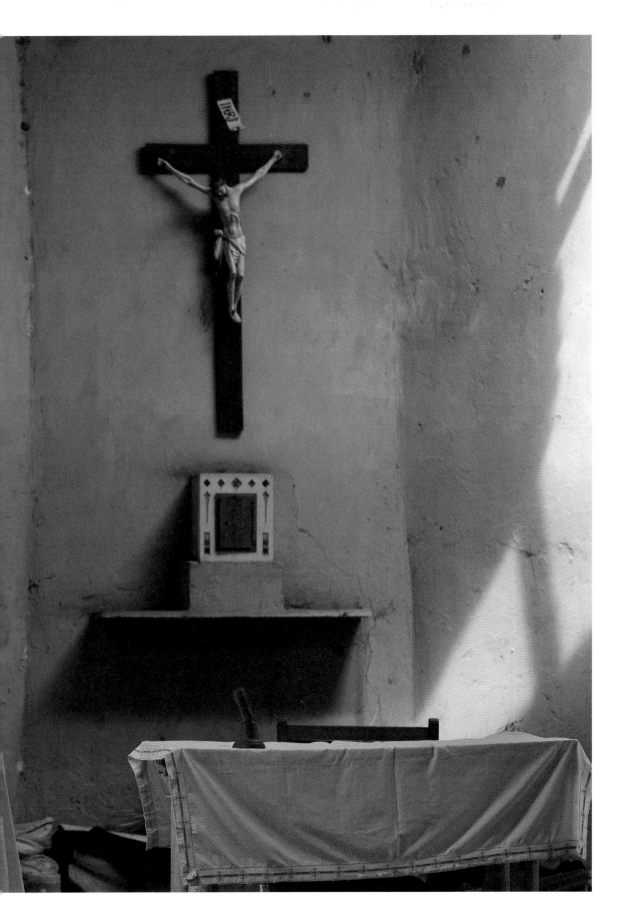

AUMU NANCY & MERCY ALOYO ›

I was abducted when I was 17 years old and 6 months pregnant. The LRA blamed me for failing to abduct other children that day and said I was bad luck. Three rebels with knives and razor blades beat me, kicked my stomach and left me with my ears, nose and lips wrapped inside paper to take to the government soldiers. I was taken to the hospital and my wounds were nursed and healed, but I lost my dignity. Even the father of my child rejected me. I was so deformed and not worthy of being associated with him anymore. I lived in the camp with my baby girl Mercy, not expecting any change to come my way. I felt very much that my life was wasted because I didn't have food, or a good house. My daughter and I were given nicknames according to my deformities. I appeared to be a burden and no one wanted to be close to me.

In 2008, African Youth Initiative Network came to my home and told me they were receiving support to assist people with injuries and in need of reconstructive surgery. I was not willing to respond because I never expected anything to be done for me. I wanted to be free of pain. They insisted and brought me to the hospital where I first received lip reconstruction. That was the first time I saw something good happen to me, and I eventually thought about going back to school. My life changed and I would look in the mirror every 20 minutes. I want to continue with my education and be able to support my daughter, and my mother who has been very pained by what has happened to me. I have been through a very hurting moment in my life but I feel more love from people who are not even related to me than I have ever felt before. My daughter keeps asking me not to remove my lips and nose again. She is very happy that I look like other mothers now. What was done to me is something that should not be done to any human being. It was a big mistake to do it to me and I felt so bitter because I never struggled with anyone for leadership. Only Joseph Kony has the right answer to why this injustice was done to me. If I had power I would help many victims with pains and injuries.

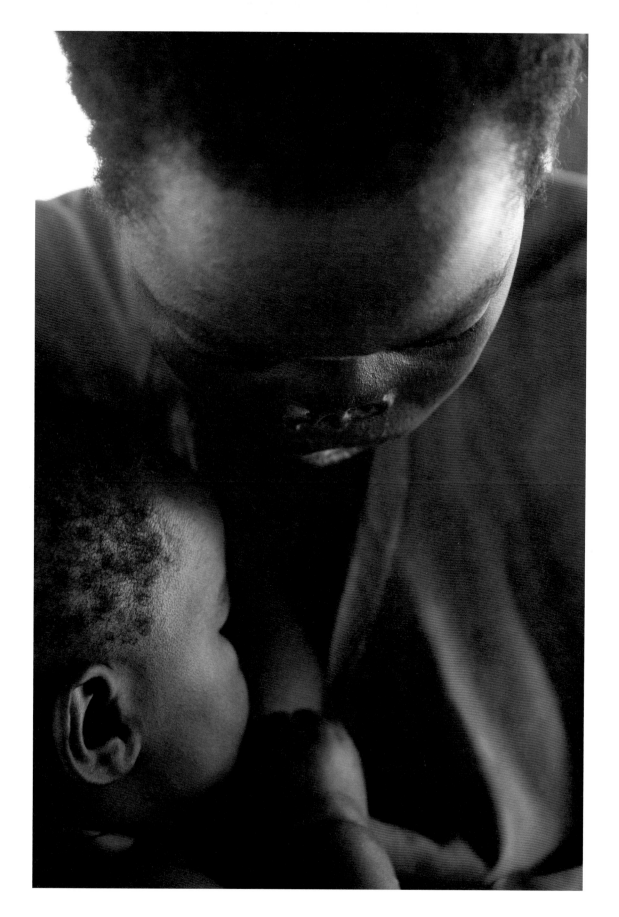

Aumu Nancy and Mercy Aloyo, Paicho IDP Camp, 2006

Alema Rose, Aler IDP Camp, 2006

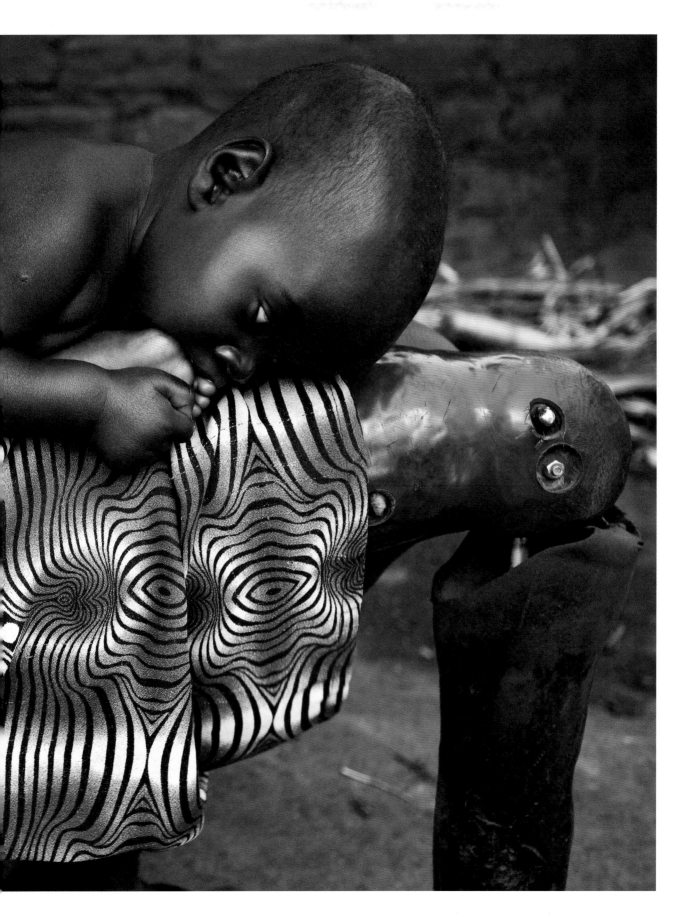

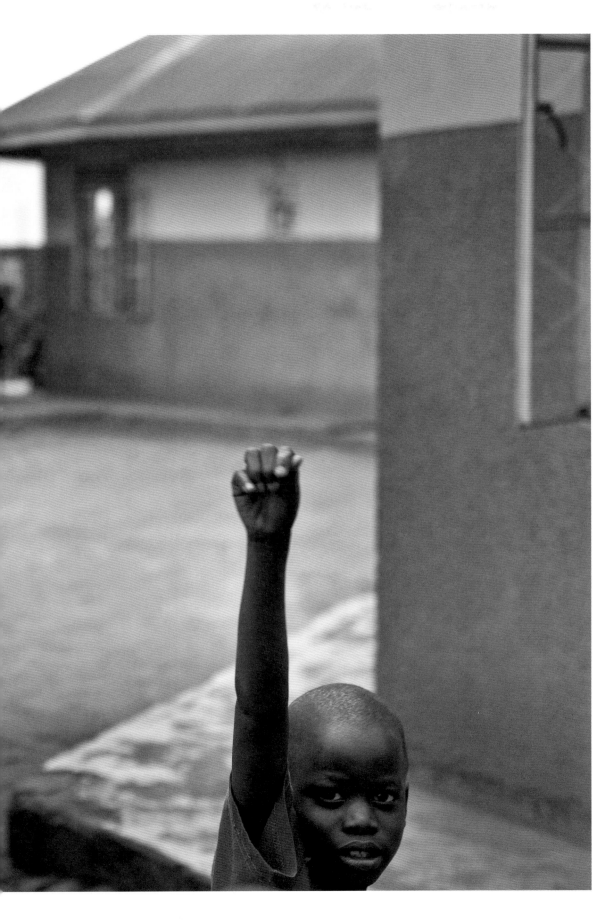

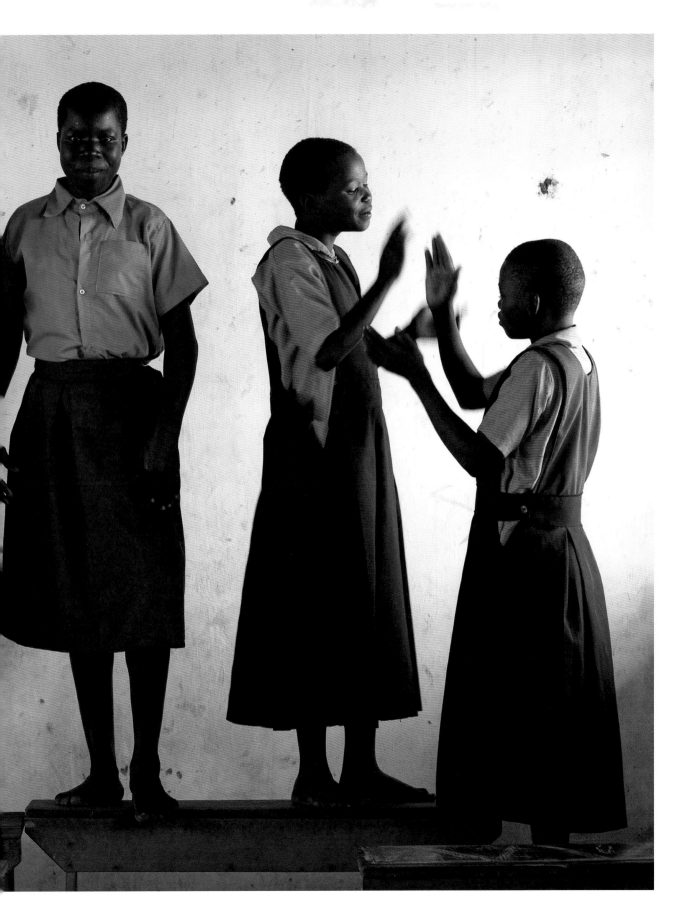

Okot Simpol, Lacor Hospital, Gulu, 2007

QUEEN AMIDA ›

My mother was poisoned when I was a year old, and my father did not live with us and died six years later. I was passed around between several aunties, an uncle, my older sister, and back to one aunt again. My family could not afford to pay for my school fees and insisted I drop out. I worked in different hotels and cooked in a bookstore for eight years, partially supporting all the members of my family. In August of 2007, I was in the local market when I met Emanuel, a young UPDF officer. He later asked me to come to Gulu with him, but my aunt refused his proposal and I escaped and travelled alone for hours to town. Emanuel is now based far away and took me to Cwero IDP Camp where his family lives before he left. He sends me a little money to pay for my school fees, and I also make a little by selling vegetables in the market on the weekends. My biggest worry is that the school raised the fee from 9,000 to 15,000 Ugandan shillings ($4.50 to $7.50 US dollars). I live alone in Cwero and my husband's male relatives do not speak to me because they do not approve that I am going to school. My female relatives do not think I should go either, but counsel me and give me a meal here and there. I dropped out of school for one term after my in-laws pressured me to quit, but Emanuel registered me again after I passed the promotional exam at the end of the term.

I am eighteen years old now, and in Primary 7. Am I happy with my new life? I am just glad I am back in school.

Queen Amida, Cwero Primary School, 2009

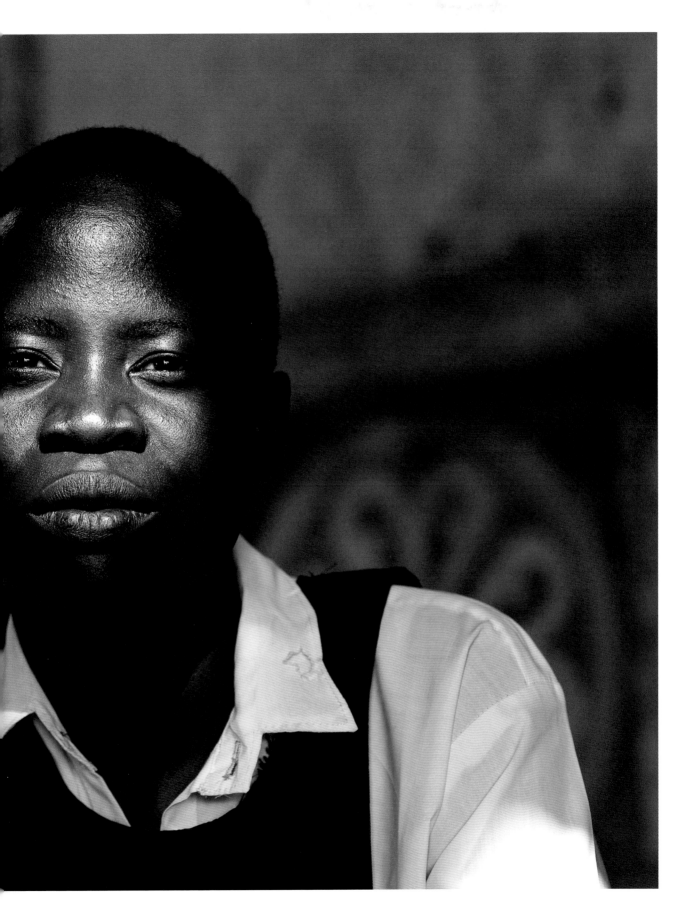

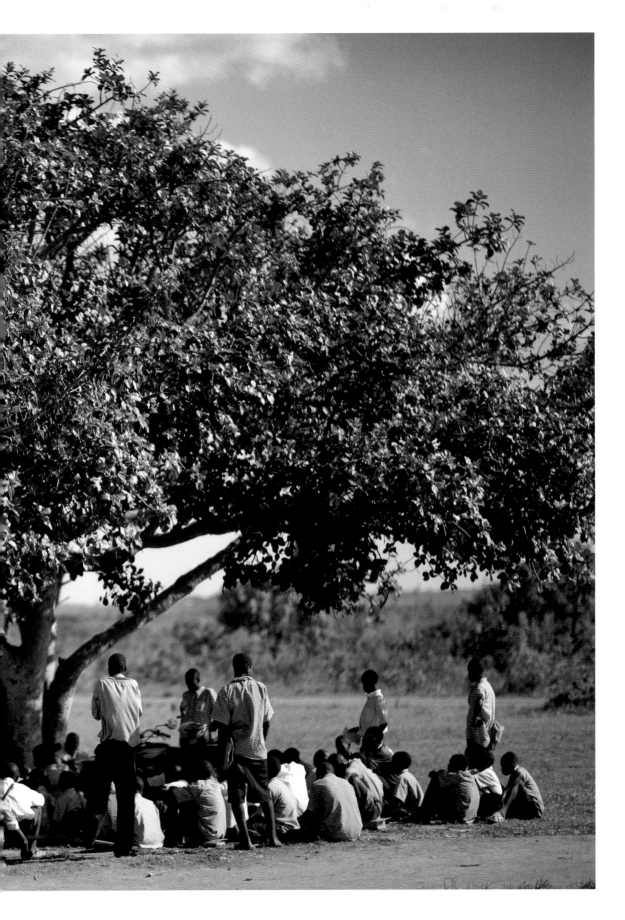

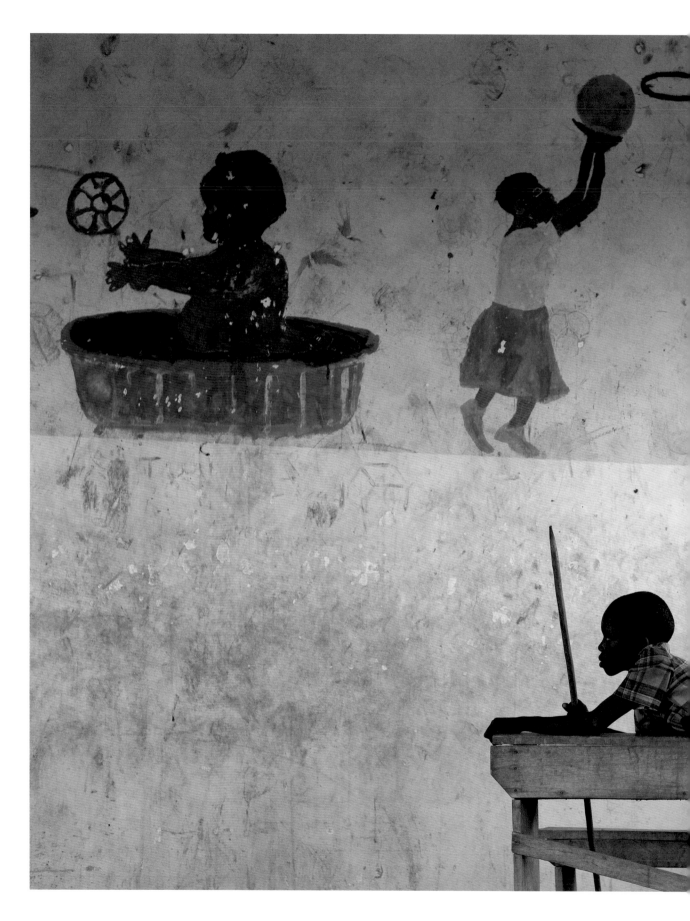

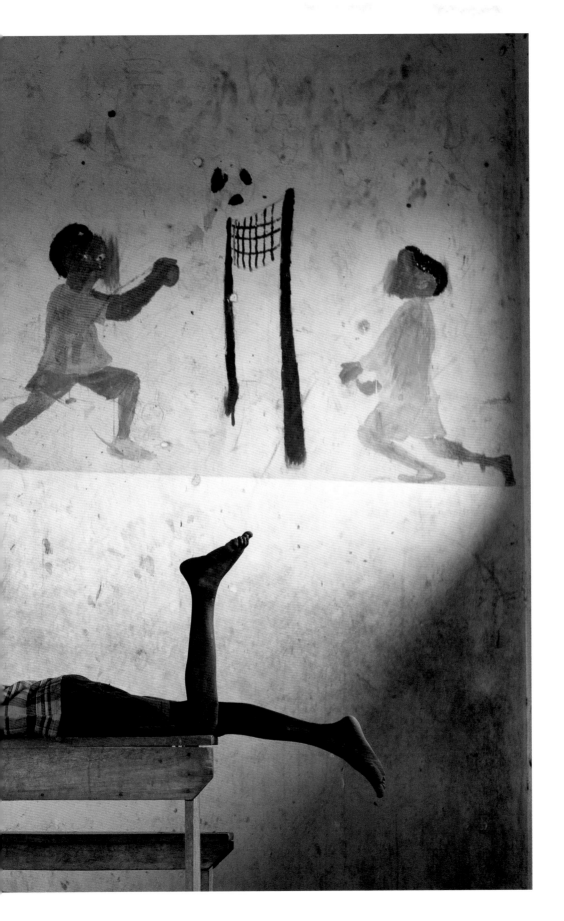

Kinyera Morish, War Child Holland Paicho Child Friendly Space, 2009

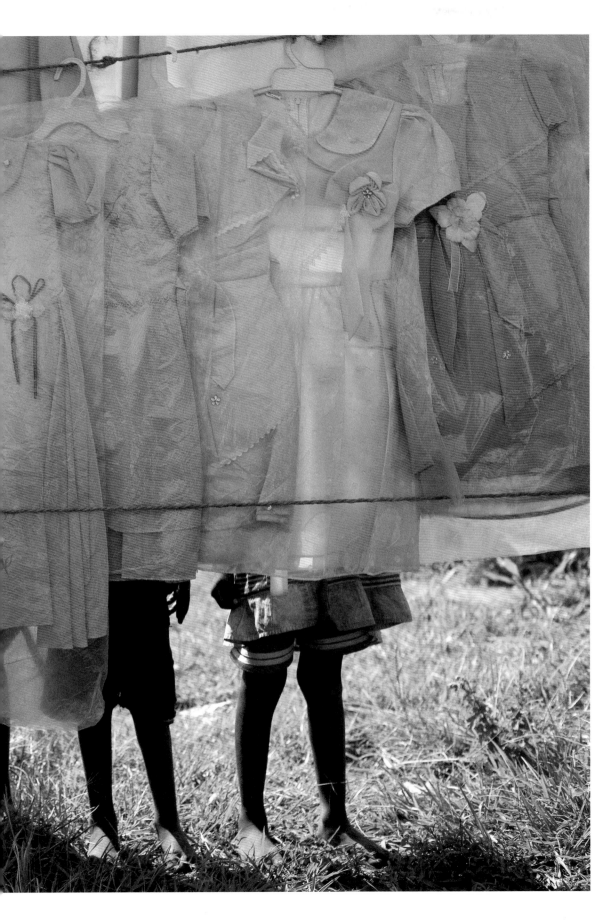

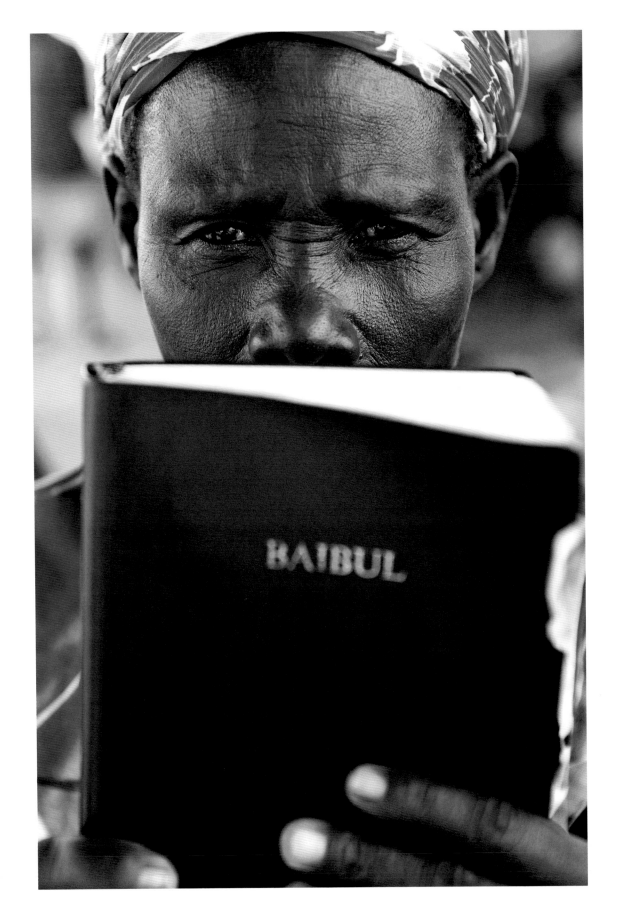

Akello Irene, Ireda IDP Camp, Lira, 2005

OBWANA PATRICK ›

He let me photograph him, but he would not talk to me. Introduced to me as an LRA abductee, at 51 years of age Obwana was clearly not a typically abducted teenager. When I repeatedly asked in different ways if he might talk to me about his fourteen years in captivity, or his escape from the LRA, or anything he might like to say for that matter, he would only respond to me by seeking monetary assistance. Almost immediately he showed me his "Certificate of Amnesty" paperwork. "Following persistent calls for a peaceful resolution of the armed conflict in the country, the Parliament of Uganda enacted a comprehensive Amnesty Act. Since then any Ugandan wishing to abandon rebellion will be granted amnesty, without risk of criminal prosecution or punishment in a national court for offenses related to the insurgency. Within the framework of the Amnesty Act, any Ugandan who has been involved in the insurgency against the Government of Uganda at any time since 1986 is entitled to amnesty and is consequently eligible for demobilization and reintegration assistance. 'Engagement in insurgency' is defined as actual participation in combat, collaboration with the perpetrators of war or rebellion or assistance in any way to the war or rebellion." (UNDDR) Frustrated that I felt the need to have verbal confirmation for what I clearly saw in his eyes, I later asked my interpreter, who lives in the same village and who I had unknowingly put at risk, as well as an NGO worker, if they might be willing to give me more insight into his background.

Of course he wouldn't talk to me about his past..."Obwana" had been a voluntary fighter, a Commander who had "masterminded killing." Infamous while in the bush, he'd come out a completely changed man.

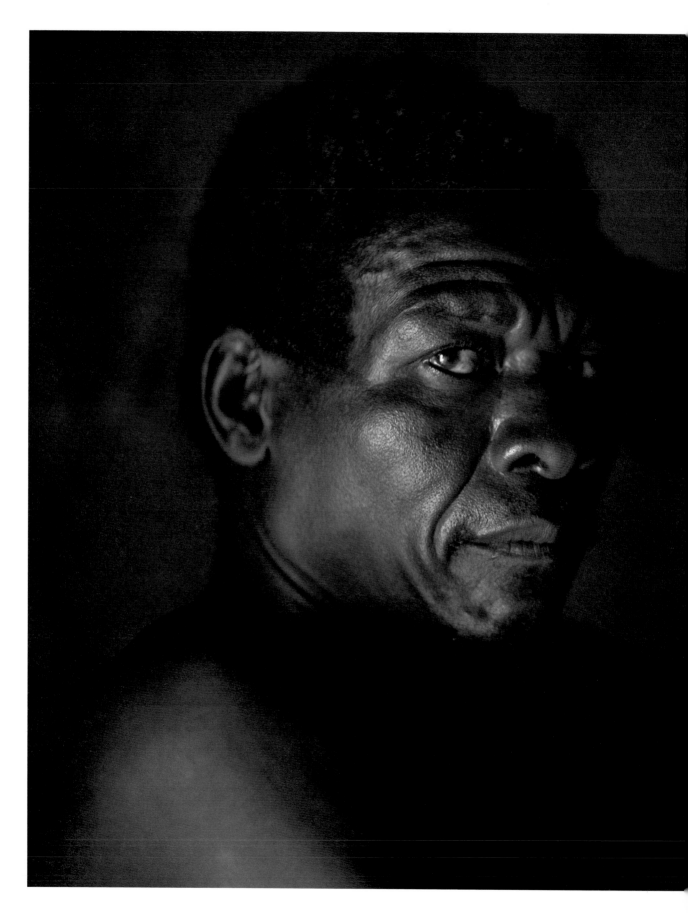

"Obwana Patrick", Koch Lila Chope, 2009

Oyella Angel and Molly Apio, War Child Holland Psychosocial Support Group for Child Mothers, St Joseph's Church, Bobi, 2009

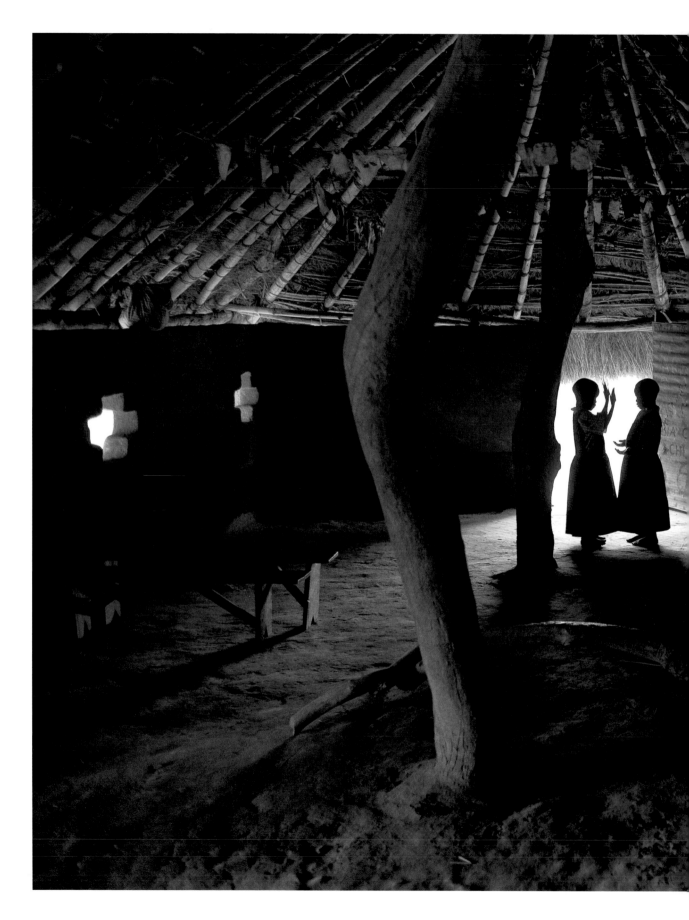

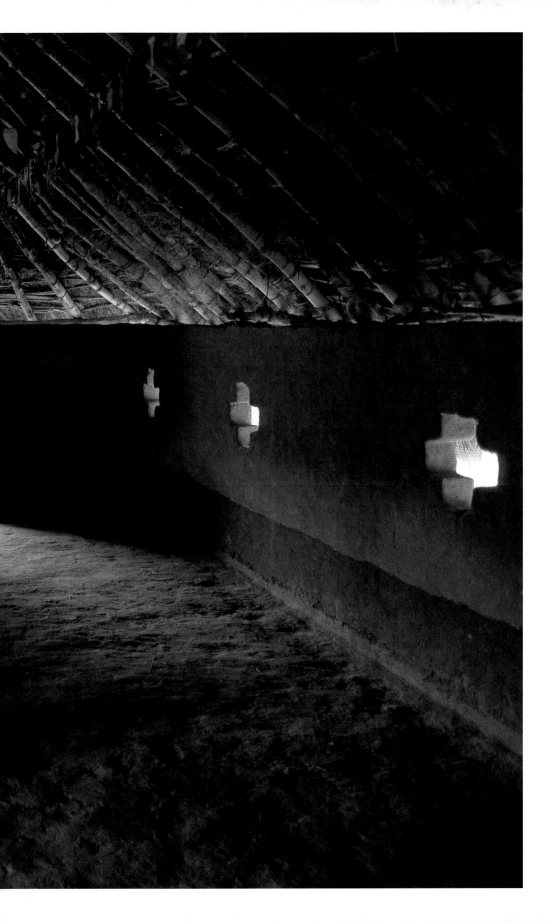

Abia Church, Abia IDP Camp, 2007

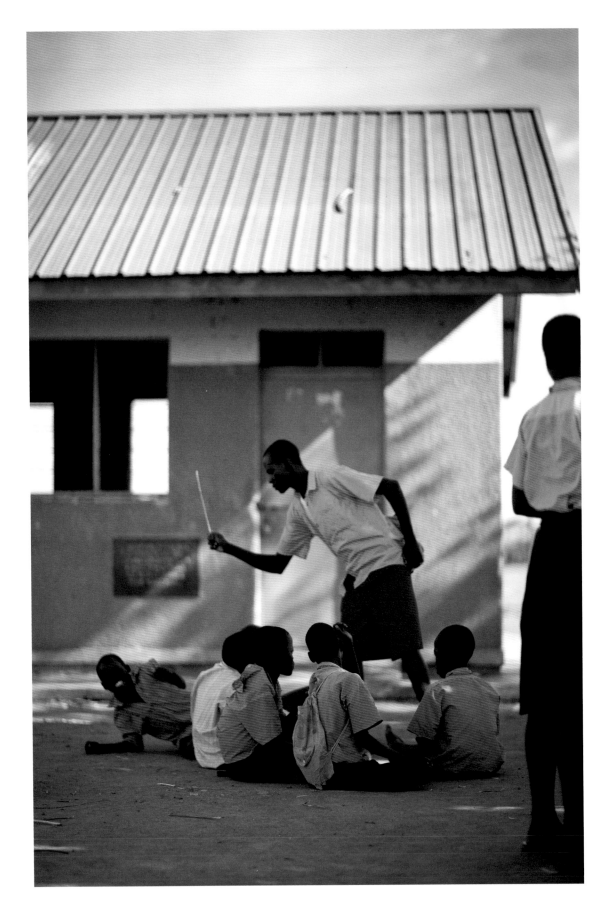

Head Boy Discipline, Rwot Abilo Primary School, 2009

AKIDI ROSE ›

The LRA had come many times before to take food and abduct children from the area, but this time they came at night and were aggressive after exchanging fire with the UPDF. They set fire to my hut while my grandmother, my mother, my three kids and I were inside. The whole area was burned, many homes, even the trading centre. My mother survived but my grandmother did not. I had an epileptic attack and I fell into the fire. I developed large keloids on my chin from the fire that were very painful and I would put cold water on them. With support from the ICC Trust Fund for Victims, the scar tissue was removed and replaced with skin from my side. I had an episode not very long ago and almost didn't come for the surgery but my mother insisted.

In 2001 my husband was hiding from the LRA in the bush. He was captured and killed in Kabala, a desolate place where the LRA would take people to be tortured. My brother-in-law found his legs, arms and head in a mass of other bodies and brought them home for burial.

My children sometimes go to the garden instead of going to school so we can have food. Other times they go to the garden early in the morning, go to school, and then come home to work.

We are surviving in God's hand.

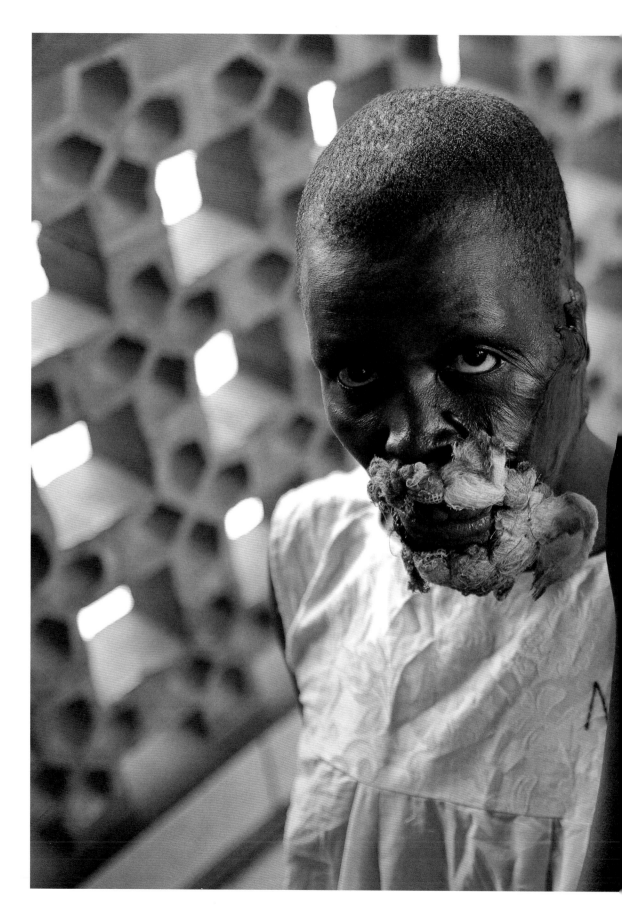

Akidi Rose, Lacor Hospital, Gulu, 2007

Anena Prudence and Uganda's Symbol of Pride, Koch Goma, 2009

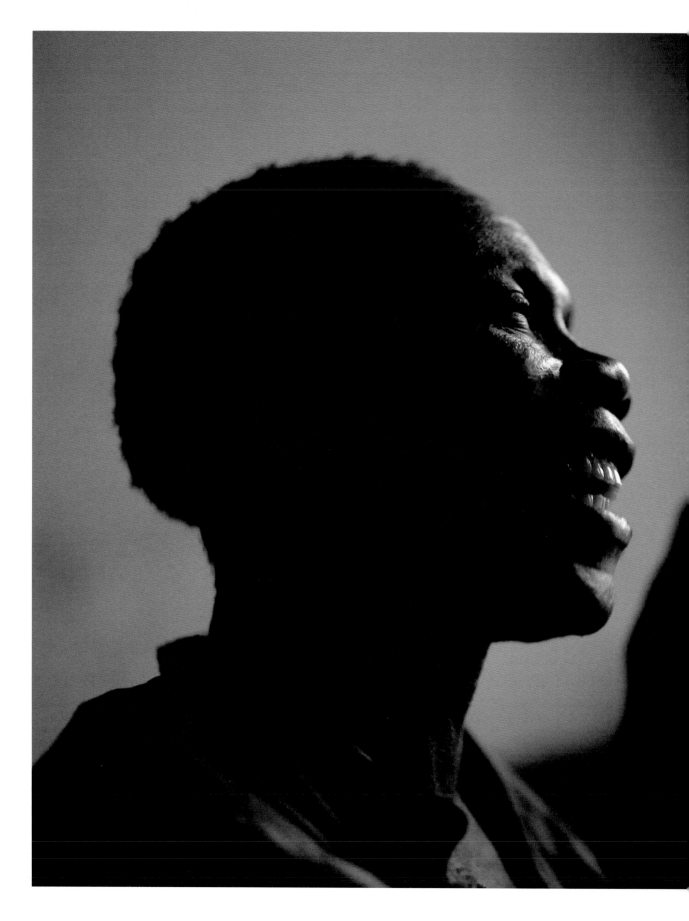

Tusayukire Wamu (Let Us Rejoice), Toasting with Another Vodka Tote, Koch Goma, 2009

Solace at Evening's End, Koch Goma, 2009

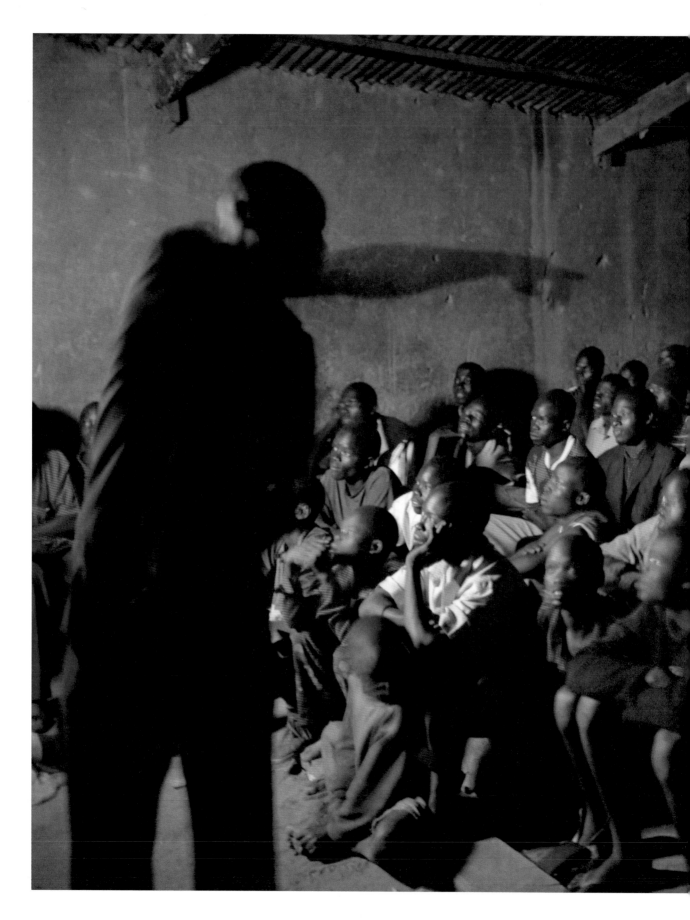

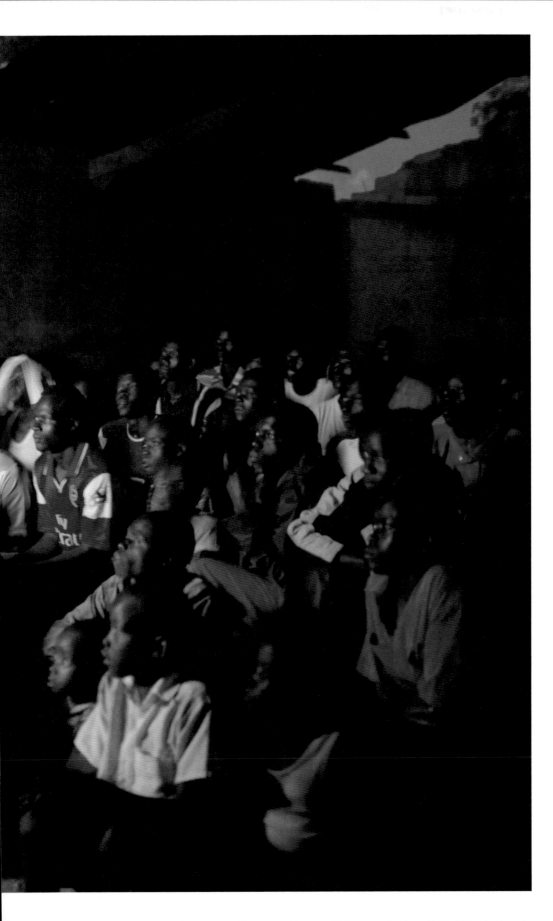

Watching Arsenal vs Fordham for 500 Shillings, Paicho IDP Camp, 2009

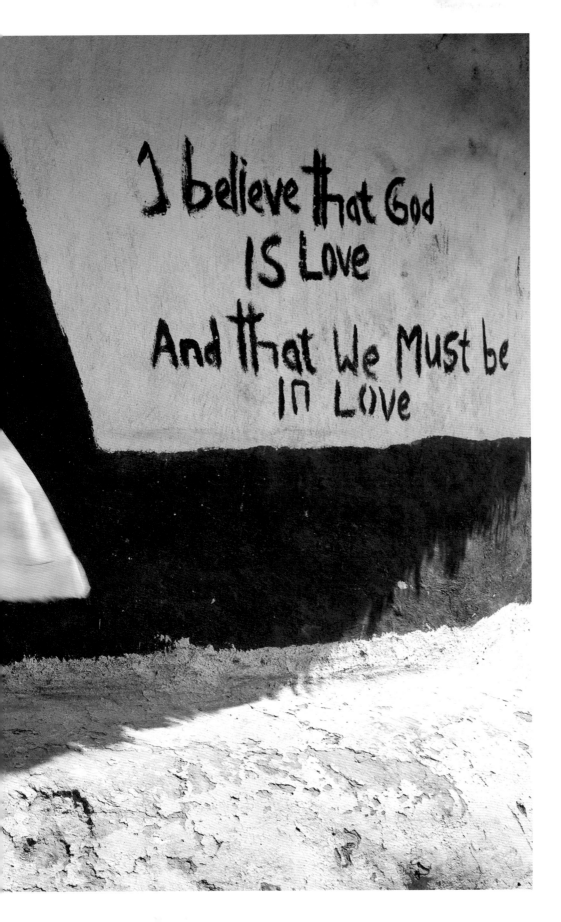

Onen Richard and Aloyo Jenifer, Paicho IDP Camp, 2009

‹ ONEN RICHARD & ALOYO JENIFER

I chose to marry Jenifer because she is my childhood girlfriend; we grew up together in the camp. Given the nature of life in the camp, it was quite hard for young people, more especially girls, to be morally upright. Jenifer has a good family background; also she was never abducted at any point and had a better moral management while growing up in the camp. We both have a lot in common that's why we chose and accepted one another. She is one of the strengths I have, she represents very well my mother. Jenifer is very helpful to my brother, very supportive to my developmental ideas and is very much behind my little success.

It's so sad that we got defeated in many valuable ways, especially in education which would have been the breakthrough in life. We are defeated but not beyond repair. I am going through many small course trainings, I am a trained community health worker, I am a counsellor, I mobilise victims of war to receive many forms of assistance and I feel there is hope for the future. I don't want to keep looking at past pains, it has always held me back and it is time to let go and move on.

I am always shocked with the serious community physical and psychosocial needs, especially women suffer the heaviest burden of war. You find a widow, struggling with her life in the society, struggling with gender negativities, stigma and exclusion from many social benefits and worst of all, a mother will always accept doing anything and everything at whatever expense in order to provide for her family. Very few ex-combatants, especially the top commanders, are assisted, so many infantry soldiers are left without assistance and people feel war is a business. The most worrying of all is many young and energetic people feel that government failed them, and there is a growing anti-government sentiment, which threatens the security.

But let's understand that this has already happened and we pray that it should never happen again. Together we must understand that there is no way we will have them come back again, actually we can't in any way afford to get a new mother, new father, brothers but we can always admit the gap their absence creates; and let's work hard and try to bridge it with passion, peace and positivity. The more we keep looking down, the more we will be recycling our problems, not looking for solutions.

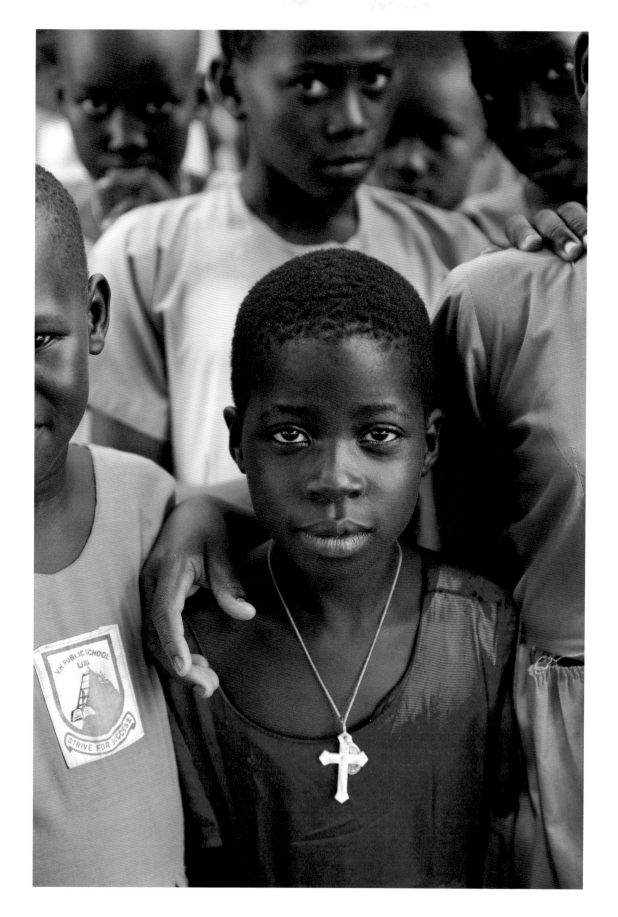

Strive for Success, Lira, 2005

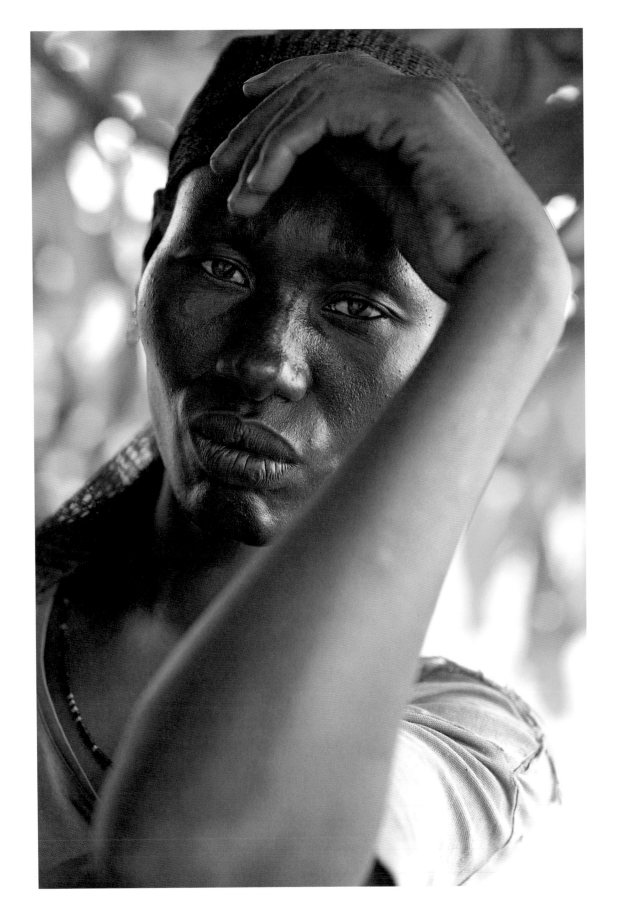

Acan Mary, Parabong IDP Camp, 2009

‹ ACAN MARY

I am fed up of living a life full of worries. I still do cry a lot every time I see how so many children in the communities are heading towards a hopeless future. We pray hard that peace remains and we stay at home, life in the camp is so humiliating that no one wants to live.

I would only feel better if I ever hear that Joseph Kony, the LRA commander, is dead. I have no excuse to want him back home alive, what he has done is too horrific to just let go. What we need to rebuild fully is not money, is not generally material assistance but we need schools where our children can study, the health centre where we can afford to get treated for malaria, clean drinking water, and let government and NGOs rehabilitate for us the community access roads. We can feed ourselves; we can train our children to work hard and live a bearable life.

I have witnessed failed families, I have seen families which may still break and there are so many children who in the real sense are already orphans even though they still have parents and close relatives. People are now out of the camp, but the refugee status in them is still intact. I don't see change in people's lives if institutions that support and promote are not rehabilitated. Life is taken for granted, home appears a more stable place to stay in the absence of LRA, but the IDP camp mentality has sunk quite deep in men, women and children most of whom were born and raised there.

As a mother and a widow, it is of grave concern that most families are now unable to raise and give their children what they deserve, which is a precondition for any peaceful society. How will the children understand development if they are not given better education? And how will they ever make positive choices if all they know is negative?

[In 2005 while living in Parabong IDP Camp, Mary's husband took his own life with cheap termite poison.]

Luroo Child and Family Programme, Unyama IDP Camp, 2009

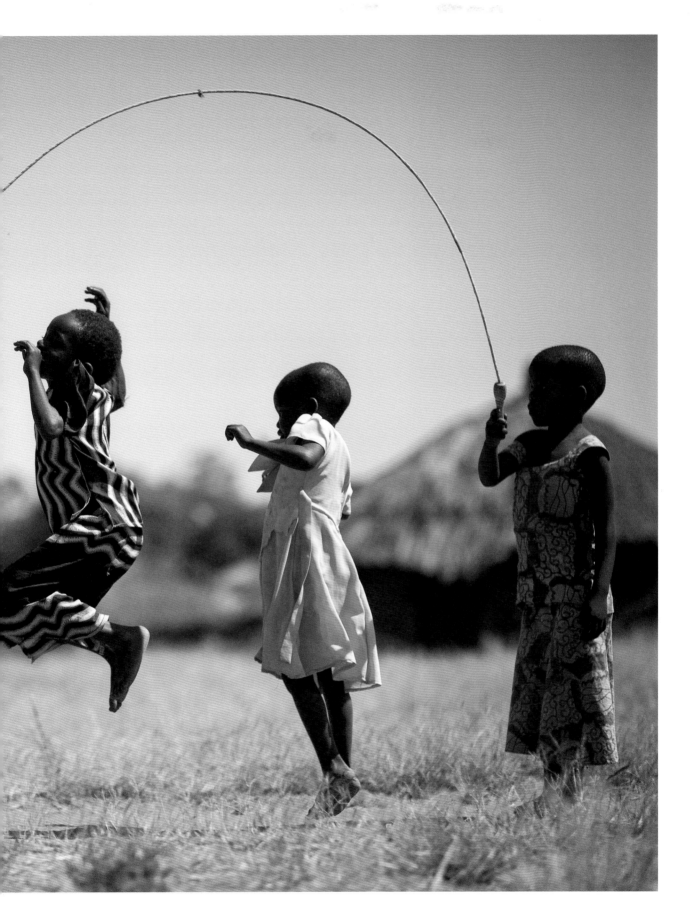

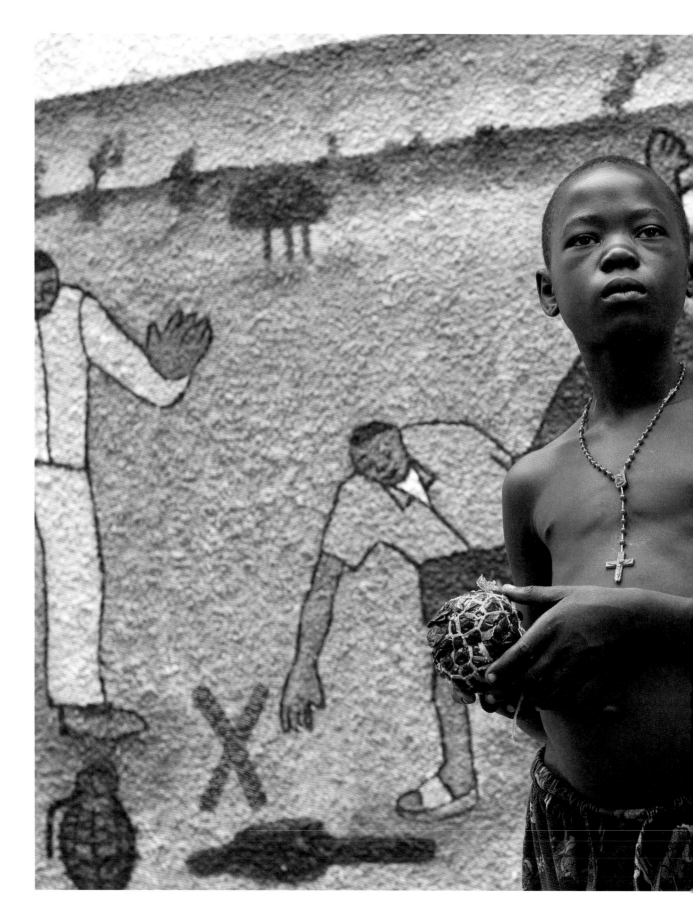

Eric Lacere, Gwoke! Pe Ikwany Jami Ataa (Be Careful! Do Not Pick Up Any Strange Objects), Keyo Primary School, 2009

Ojok Brian, Awach IDP Camp, 2009

Lanyero Immaculate and Abong Vicky, War Child Holland Psychosocial Support Group, Patek Primary School, 2009

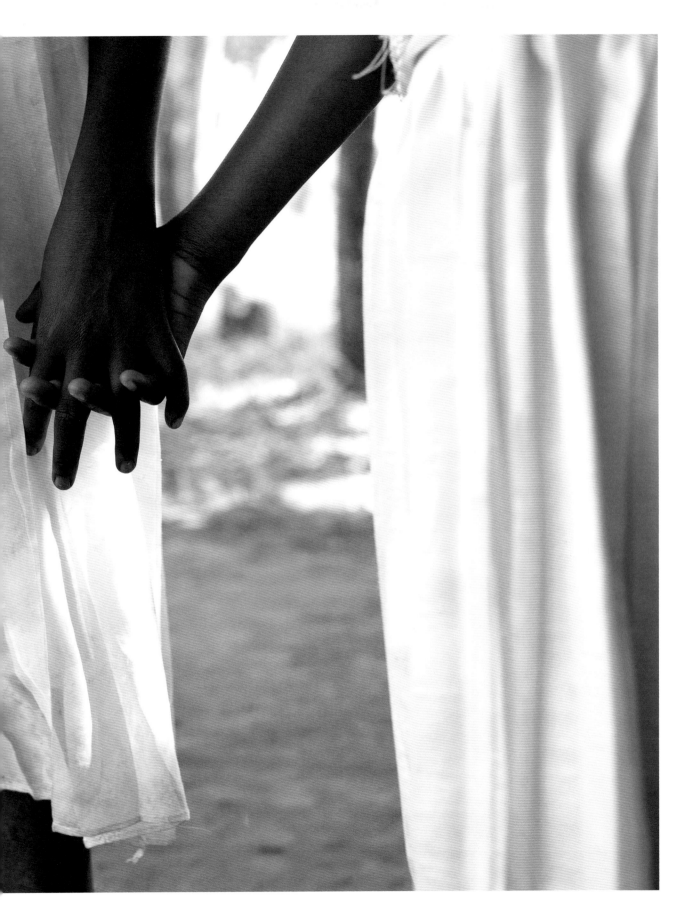

Lakereber Mercy and Adong Patricia, Palenga Village, 2009

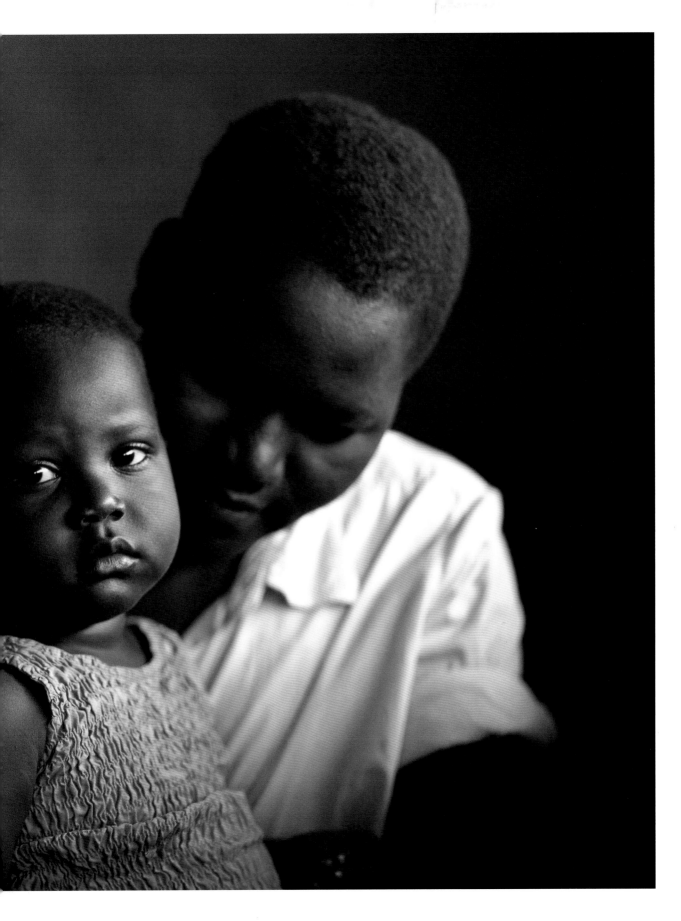

All photographs and text:
© 2010 Heather McClintock, USA,
www.heathermcclintock.com

© 2010 Schilt Publishing, Amsterdam,
www.schiltpublishing.com

Design:
Teun van der Heijden, Heijdens Karwei, Amsterdam,
www.heijdenskarwei.com

Text correction:
Kumar Jamdagni, Zwolle
www.language-matters.nl

Printing:
Wachter GmbH, Bönnigheim,
www.wachter.de

ISBN 978 90 5330 697 0

Distribution in North America:
Ingram Publisher Services
One Ingram Blvd.
LaVergne, TN 37086
IPS: 866-765-0179
Email: customer.service@ingrampublisherservices.com

Distribution in all other countries:
Thames & Hudson Ltd
181a High Holborn
London WC1V 7QX
Phone: +44 (0) 20 7845 5000
Fax: +44 (0) 20 7845 5050
e-mail: sales@thameshudson.co.uk

This book is lovingly dedicated to Victor Ochen, who gracefully reminded me to see what is best, despite knowing the worst. To my Mom, whose strength, independence and generosity has molded my life. To Mark Malloy, who honors me by insisting I be true to myself. To the people of Uganda who respectfully let me into their lives, bared their souls, and opened my heart with their resilience, humor and hope.

Greg Allen, Camille Seaman, Eric Keller, Laurie Lambrecht, La Nola Kathleen Stone, Kristen Vermilyea Harbaugh, Mary Virginia Swanson, Omar Mullick, Shams Lalji and Irene Nakimuli, Greg Williams and Alice Neff, Tom and Mary Leach, Bob Hite and Belinda Ballew, Nessa Flax, RPM, Onen Richard, Arne Hoel and Mach Arom – Skywalker; for inspiration, contemplation, translation, pure gearhead joy on the road and in communion, but mostly for your love and a sometimes needed cattle prod.

Maarten Schilt, Colin Finlay, Bill Clift, Sam Abell, Stanley Greene, Santiago Leon, Jamie Wellford, Darius Himes; for balls of steel, voices of shadow and silk, men in uniform and martinis, for insisting I not give up on my voice, for simply showing up when you didn't have to.

Mark Livingstone, Robyn Hails, Mick Trant, Phoebe McKinney, Irene Muller and Lotte Vermeij; for ballads at Bambu, dirt bikes and dreaming, waterfalls and wrecks, Bertram and being on the road, duty, honor, camaraderie and champagne, those few precious moments of perfect stillness. Beautiful Gulu Sheeps, you first be happy. Levi McGrath, whose Children of War song re-ignited the fire when the post-conflict destination crowd bunched the knickers.

My deepest gratitude to Maarten Schilt, the Nationale Postcode Loterij, Oxfam Novib, War Child Holland, Evelien Schotsman and Teun van der Heijden for making this book a reality. These NGOs have graciously allowed me to work with them intimately, have generously given their support or are valuable sources of information. For more on the conflict in Uganda, recovery efforts or to lend assistance:
African Youth Initiative Network,
http://www.ayinet.or.ug
Resolve Uganda,
http://www.resolveuganda.org
Medical Teams International,
http://www.medicalteams.org
Oxfam Novib,
http://www.oxfamnovib.nl
War Child Holland,
http://www.warchild.org
Echo Bravo,
http://www.echobravo.net
DDG,
http://www.danishdemininggroup.dk
!Enough,
http://www.enoughproject.org
International Rescue Committee,
http://www.theirc.org
GuluWalk,
http://www.guluwalk.com
Genocide Intervention Network,
http://www.genocideintervention.net

All interviews were conducted in Luo (Langi and Acholi dialects) and translated into English. Every story is written in the actual words of the individual; however, at times it was necessary to find an equivalent or approximation into English.